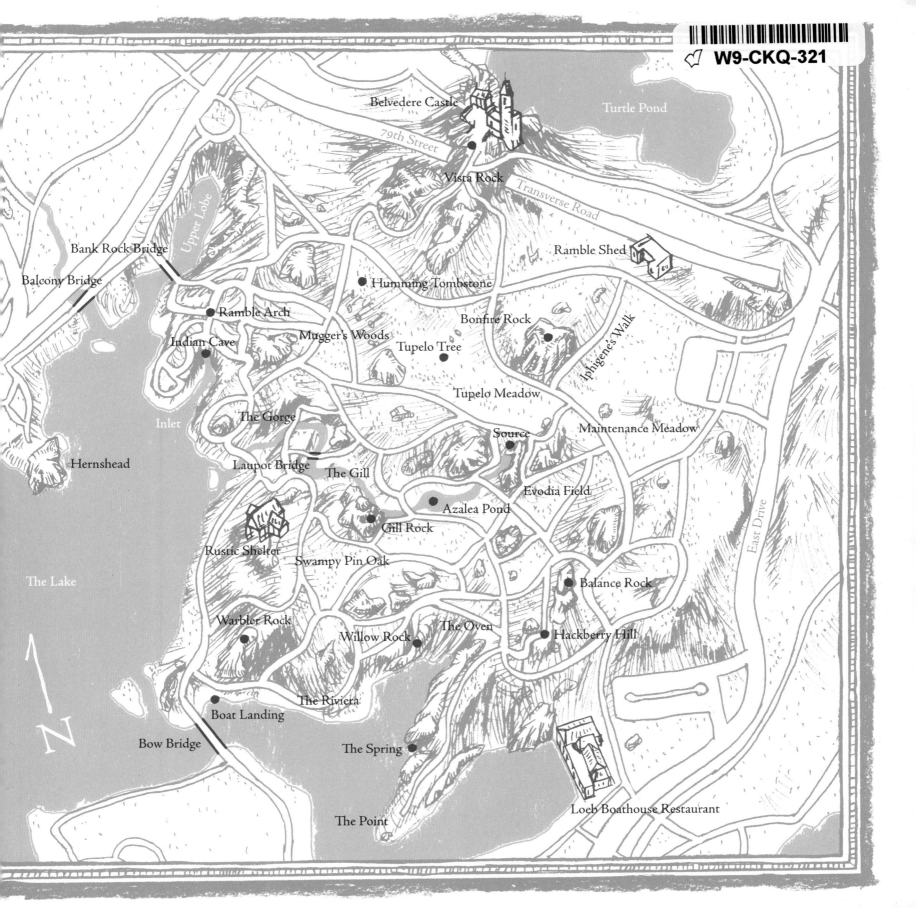

Belvedere Castle

Turtle Pond

79th Street

Vista Rock

Transverse Road

Ramble Shed

Bank Rock Bridge

Upper Lobe

Balcony Bridge

Humming Tombstone

Ramble Arch

Bonfire Rock

Iphigene's Walk

Indian Cave

Mugger's Woods

Tupelo Tree

Tupelo Meadow

Inlet

The Gorge

Source

Maintenance Meadow

Hernshead

Laupot Bridge

The Gill

Evodia Field

Azalea Pond

Gill Rock

Rustic Shelter

Swampy Pin Oak

The Lake

Balance Rock

East Drive

Warbler Rock

Willow Rock

The Oven

Hackberry Hill

The Riviera

N

Boat Landing

Bow Bridge

The Spring

The Point

Loeb Boathouse Restaurant

W9-CKQ-321

THE RAMBLE
IN CENTRAL PARK

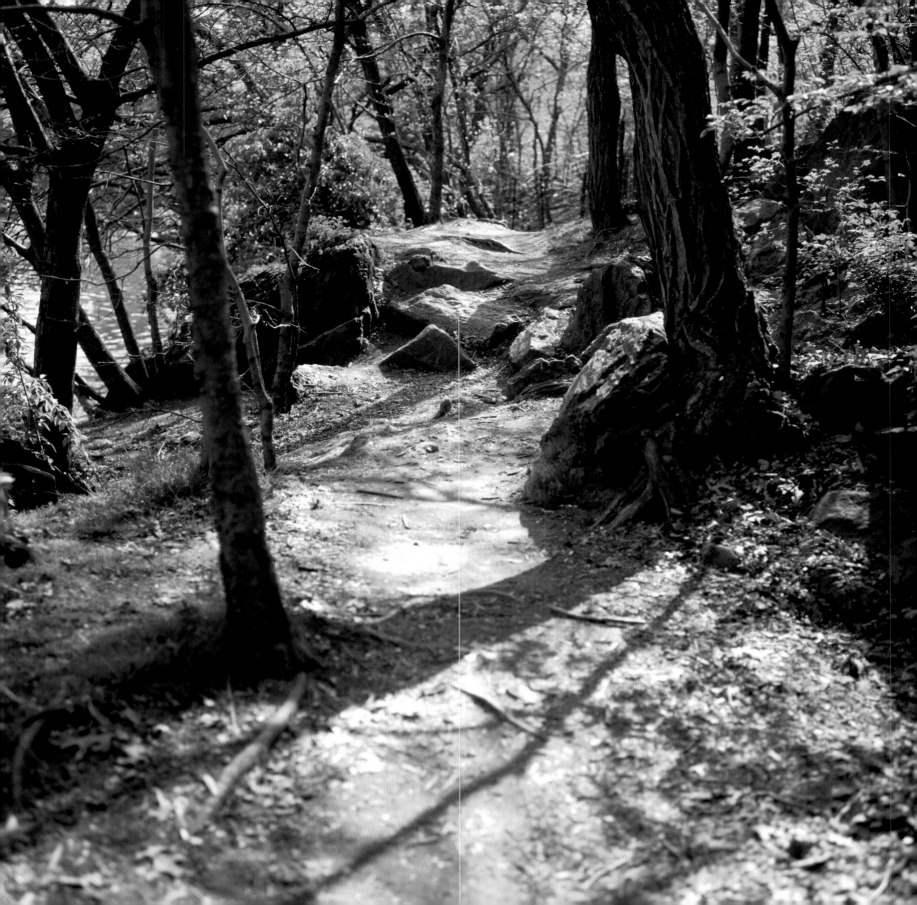

THE RAMBLE
IN CENTRAL PARK
A WILDERNESS WEST OF FIFTH

❧ ROBERT A. McCABE ❧

ABBEVILLE PRESS PUBLISHERS

NEW YORK LONDON

Front cover: see page 31
Back cover: see page 99

EDITOR: Susan Costello
PRODUCTION EDITOR: Michaelann Millrood
PRODUCTION MANAGER: Louise Kurtz
DESIGNER: Misha Beletsky
MAP: Christopher Kaeser
PREPRESS: Dijifi LLC, New York / Jesse Crowder
PRODUCTION ADVISER: Susan Medlicott
PRINTING AND BINDING: Trifolio Srl, Verona, Italy

First Edition
2 4 6 8 10 9 7 5 3 1

Library of Congress Cataloging-in-Publication Data
is available upon request.

For bulk and premium sales and for text adoption procedures, write to Customer Service Manager, Abbeville Press, 137 Varick Street, New York, NY 10013, or call 1-800-ARTBOOK.

Visit Abbeville Press online at www.abbeville.com.
Robert A. McCabe's web site is www.mccabephotos.com.

FOR JIM AND MARY EVANS

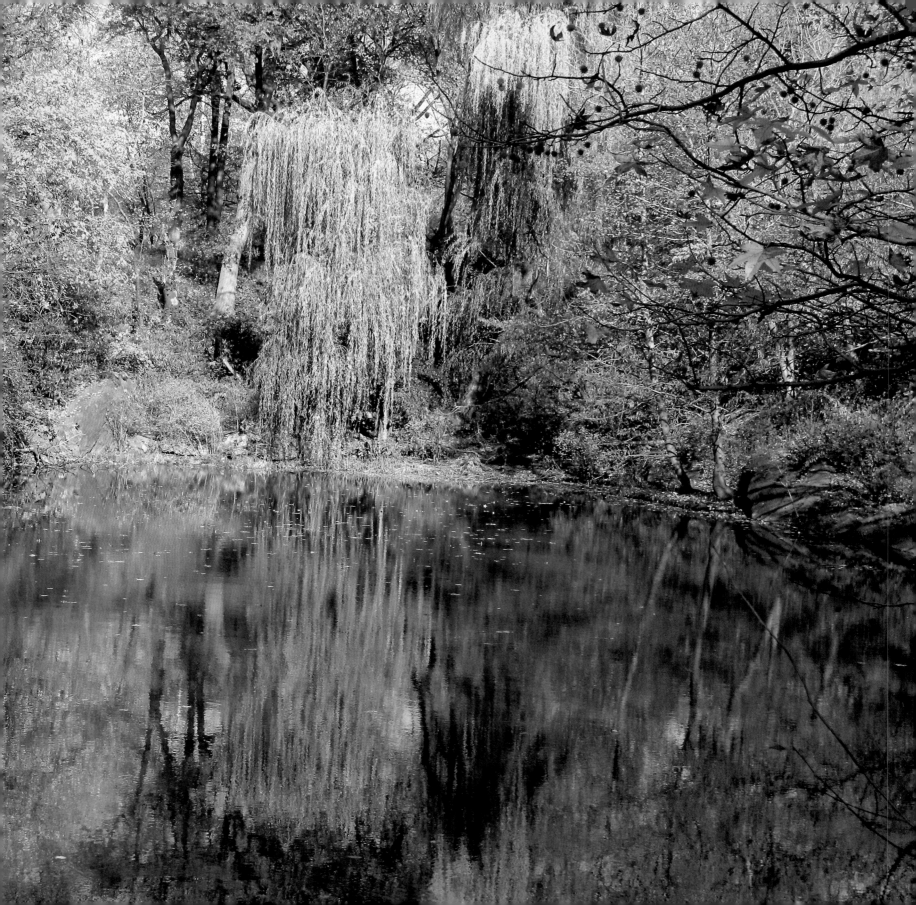

CONTENTS

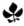

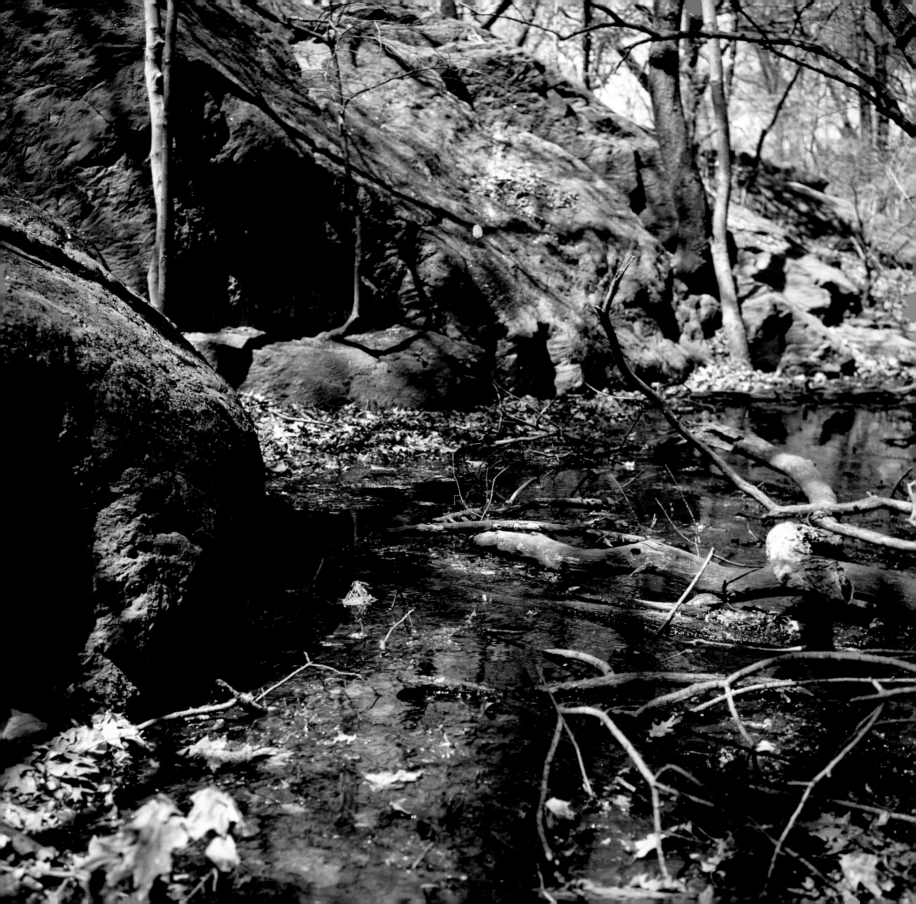

PHOTOGRAPHER'S NOTE

Every few years, at Thanksgiving, I travel to Jackson Hole, Wyoming, to photograph the scenery and wildlife in the company of my aunt, who at the age of ninety-nine is a working photographer based in Jackson. Three years ago I returned from such a visit and wandered into the Ramble. It was late fall, and the vistas had opened as the dense foliage of summer had fallen. I could not help but think how extraordinary it was to have here in the heart of Manhattan this wild area fronting on a beautiful lake. I contemplated the photographic potential of the area, and how even a pocket like the Ramble could contain on a small scale many of the features that the vast tracts of Wyoming offer. (My aunt will ask to see the photos of the moose and the bear and the elk!)

So, I set out to photograph the Ramble through the changing seasons, concentrating on the unfolding of spring's flowers and light green leaves, the development of fall with rapidly changing colors and views, and the winter snow that transforms the Ramble into another, unrecognizable world. For this project I used a Rolleiflex with an f 3.5, 75 mm Zeiss Tessar lens, and a Canon G-10 with an f 2.8 lens and 5X zoom. (I discovered how to make friends in the park: older folk greet you with "Wow, a Rollei," and the younger people ask "Hey, what's that?")

In a lengthy July 1860 essay about the Ramble, a *New York Times* reporter had two very serious complaints: the paucity of benches, and an absence of signs showing the visitor how to get OUT of the Ramble! There are still no signs, and it is still not easy to get out exactly when or where you want to. The reason is simple: the Ramble's designers' goal was to make this small area of thirty-eight acres seem large and complex by utilizing winding, twisting paths, and shrubbery and rock hills that blocked visibility. So there is really no logical way to organize a tour of the Ramble, and likewise there is absolutely no way to give directions to someone in the Ramble. Our challenge was to find a way to organize the photographs with some coherency. The solution: we created four imaginary "neighborhoods" or quarters within the Ramble. (Thank you, Abbeville Press.) Hopefully these sections, in concert with Chris Kaeser's remarkable map, will enable a visitor to unravel the topography of the Ramble with relative ease. Chris's map, specially prepared for this book, is the most comprehensive I have seen.

Our neighborhoods move, with some imprecision, from east to west. The first includes the Point, which is easily accessed from the Loeb Boathouse Restaurant, and its northern rock fields, including Balance Rock and Hackberry Hill. The second area includes the Riviera, Bow Bridge, the Rustic Shelter, the Oven, and Warbler Rock. The third is the Valley (if I might use Wyoming terminology) of the Gill Creek, from the small, still pool nestled in rocks at its source, to Azalea Pond, then through fields, through channels in bedrock, and finally to the dramatic Gorge, where it enters the Lake. The fourth neighborhood is simply the West. It is accessed by Bank Rock Bridge, and includes the Arch, the Cave, the Inlet, Mugger's Woods, and the Upper Lobe.

I am inordinately proud of my collaborators in this project. Their love for the Ramble is palpable. Doug Blonsky, who has devoted his life to the park; Cal Vornberger, the outstanding wildlife photographer; Regina Alvarez, who can name any plant in the Ramble for you before you finish asking; Sidney Horenstein, whose knowledge of the complex geology of the Ramble is outstanding; Elizabeth Barlow Rogers, the founding president of the Central Park Conservancy; and, of course, E. B. White and C. Stevens, not strictly collaborators but very much with us in spirit, as undisputed victors in the Battle of the Ramble. (You will find out more about that in a minute.)

As this book has developed I have had the opportunity to discuss it with many New Yorkers, including some who can see the Ramble from their apartments. I am amazed that many have never visited this magical place, and many did not even recognize the name. I hope this book will open new vistas for the enjoyment of the Ramble for New Yorkers and visitors alike.

—Robert A. McCabe

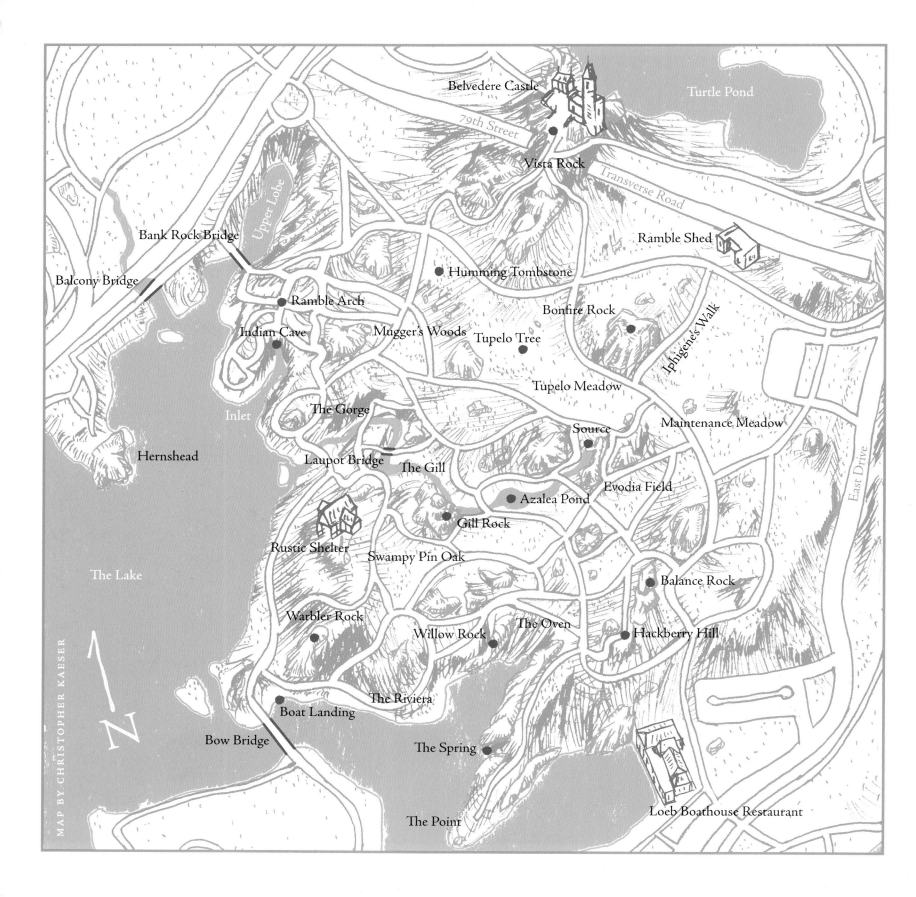

Belvedere Castle

Turtle Pond

79th Street

Vista Rock

Transverse Road

Ramble Shed

Bank Rock Bridge

Upper Lobe

Humming Tombstone

Balcony Bridge

Ramble Arch

Bonfire Rock

Iphigene's Walk

Indian Cave

Mugger's Woods

Tupelo Tree

Tupelo Meadow

The Gorge

Inlet

Maintenance Meadow

Source

Laupot Bridge

Hernshead

The Gill

Evodia Field

Azalea Pond

Gill Rock

East Drive

Rustic Shelter

Swampy Pin Oak

The Lake

Balance Rock

Warbler Rock

The Oven

Willow Rock

Hackberry Hill

The Riviera

Boat Landing

Bow Bridge

The Spring

N

The Point

Loeb Boathouse Restaurant

INTRODUCTION

Central Park is a great work of art, and most appropriately has been an inspiration to painters, photographers, and writers ever since its creation. The Ramble, completed in 1859, has been a particular focus of the photographer's art, and Robert McCabe's images are a valuable contribution to this venerable tradition. McCabe appreciates everything from the smallest detail of an unfurled leaf to the largest vista of the Lake and the New York City skyline beyond, and his scope leaves no leaf unturned.

A "ramble," defined as both "a walk without a definite route, taken merely for pleasure," or "an aimless amble on a winding course," has been in the English language since the sixteenth century, though as an intentionally designed landscape it was first practiced in the nineteenth century, and perfected in Central Park by designers Frederick Law Olmsted and Calvert Vaux.

Originally a barren stretch of rock outcrops abutting a vast swamp, the Ramble area was transformed into an intimate woodland to complement the infinite lakes and meadows and formal geometric settings such as the Mall and Bethesda Terrace. In planning for the main woodland, Olmsted fantasized "[t]here can be no better place than the Ramble for the perfect realization of the wild garden." He instructed his superintendent of plantings, Ignaz Pilat, to create a quasi-subtropical setting similar to those he had experienced in Panama and the South. These landscapes were characterized by the visual interplay of textures, colors, and materials—brushed with dappled light and shade—and combined with the sounds of babbling brooks, rushing streams, and chirping birds that were, in his words, meant to "excite the childish playfulness and profuse careless utterance of Nature" and to evoke mystery, obscurity, and rapture in the mind of the Ramble visitor.

With its twisting paths, meandering streams, dramatic shifts in topography, bold rock outcrops, intimate glades, dense plantings, and a fanciful variety of rustic benches, fences, shelters, stone and wooden arches—even a dark and forbidding cave—the Ramble is the best example of the designers' "passages of scenery" that compose and recompose themselves as the visitor strolls through the landscape. In contrast to the Ramble's internal obscurity and complexity, the visitor is teased by external views that open to completely different and breathtaking experiences—Bow Bridge, Bethesda Terrace, Hernshead, Balcony Bridge, the Lake, the bustling traffic on the Drive to the east, Belvedere Castle, and the Upper and Lower reservoirs (the latter transformed into the Great Lawn by 1937).

In 1866, the *New York Evening Post* declared that "The Ramble is at present the very soul of the Park." Today, with the restoration of its Lake shoreline in 2009, and the ongoing restoration of its interior woodlands by the Conservancy, we believe that the Ramble is indisputably still the soul of Central Park. It is clearly the wild and dramatic place it was intended to be, as attested by McCabe's photographs of its splendid landscapes in multiple seasons. Photography is one of the park's major activities, and this book is a testimony to the countless individual visions that each of the thirty-five million visitors bring to their time in the park. With its detailed map and informative essays, this book offers armchair travelers anywhere in the world the opportunity to take a virtual ramble in the soul of our park.

The Central Park Conservancy is committed to the restoration of the entire Ramble. We invite you to join us as a member of the Conservancy, to ensure that our wilderness west of Fifth is as beautiful in the future as it is in the pages of this book.

—Douglas Blonsky
President of the Central Park Conservancy and Central Park Administrator

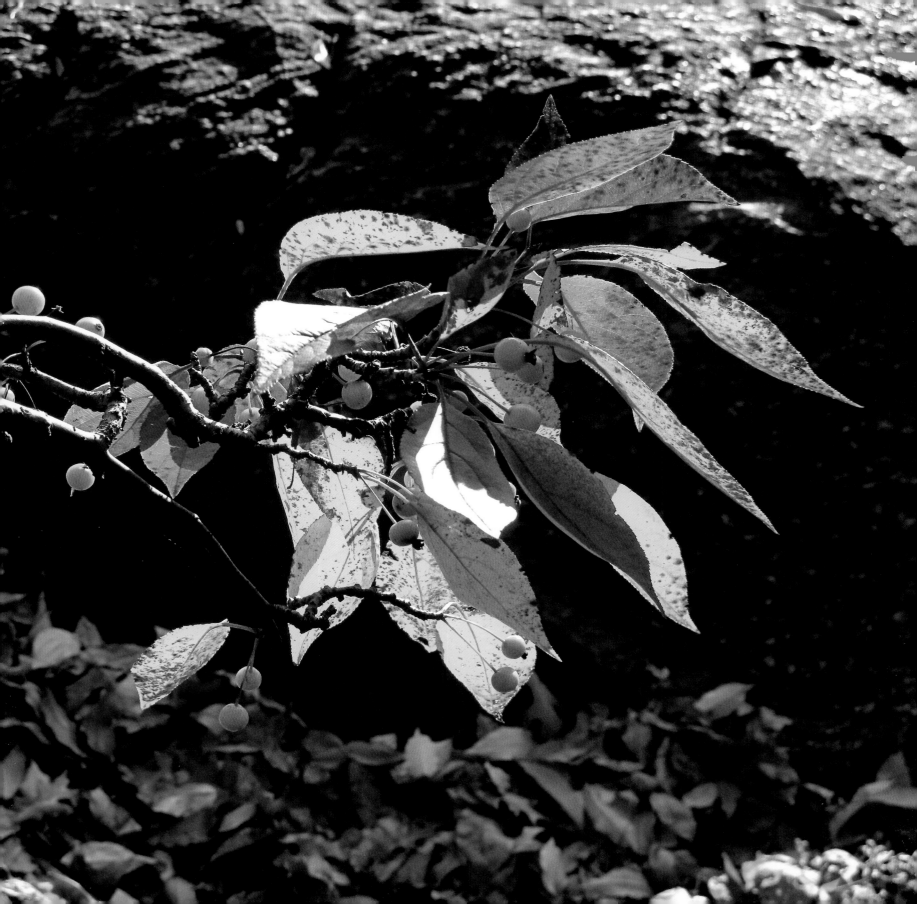

Yet the greatness of Central Park has another, deeper source: the very idea that wildlife can exist and even thrive in the middle of a city like New York. It seems remarkable that a pair of wood thrushes, a diminishing species in America, birds of deep woods and sylvan glades, would choose to build a nest and raise a family in Central Park's Ramble, as they did a few years ago. On early May and June mornings and then just around dusk, the Ramble wood thrush gave regular concerts. And numbers of city people passing through stopped and listened to its penetrating, flutelike, heart-stoppingly beautiful song: Ee-oh-lee, ee-oh-loo-ee-lee, ee-lay-loo.

On June 22, 1853, before Central Park even existed on paper, Henry David Thoreau heard a wood thrush singing as he took his evening walk on Fair Haven Hill near Walden. He described the experience in his *Journal*:

All that is ripest and fairest in the wilderness is preserved and transmitted to us in the strain of the wood thrush. This is the only bird whose note affects me like music, affects the flow and tenor of my thought, my fancy and imagination. It lifts and exhilarates me. It is inspiring. It is a medicative draught to my soul.

Though the wood thrush in the Ramble sings its song in the heart of the city, its mysterious power to evoke deep woods and the wildness of nature is undiminished. As Thoreau explained it:

It is in vain to dream of a wildness different from ourselves. There is none such. It is the bog in our brain and bowel, the primitive vigor of Nature in us, that inspires the dream.

—From *Red-Tails in Love* by Marie Winn

ROBERT MOSES AND THE BATTLE OF THE RAMBLE

With these headlines, on May 30, 1955, *The New York Times* trumpeted the news that Robert Moses, Commissioner of Parks, had let a design contract for a fenced, indoor and outdoor recreation center in the Ramble, occupying all but its periphery. The *Times* ran a four-column rendering of the proposed building, including a large map of the locations of game tables, as well as facilities for croquet, horseshoe pitching, and shuffleboard. The indoor facility was to have a television room, a radio room, and a music room with a piano, as well as a record player and records. During the ensuing months, a heated battle broke out, spearheaded by the Linnaean Society, and supported by the *New Yorker* in two "Talk of the Town" pieces:

"TALK OF THE TOWN" JULY 30, 1955

Just south of the Seventy-ninth Street transverse in the Park and lying between the East Drive and the West Drive, there is a tract of wild land called the Ramble. Like most urban jungles, it has a somewhat shabby appearance. It is thickly wooded and rocky, and in the middle of it there is a miniature swamp. Paths twist and turn back upon themselves, and peter out in dirt trails leading down to the shores of the Seventy-second Street Lake. Except for one peculiarity, the Ramble is no different from dozens of fairly green mansions inside the city limits. What distinguishes it is the fact that, in the magical moments of migration, birds descend into the place in great numbers and in almost unbelievable variety. They ignore other attractive areas in the Park and drop straight into the Ramble. The reason is simple. The place offers good cover and it has water, the two requisites for the peace of mind of small songsters. Because of its phenomenal popularity among transient birds, the Ramble is known to ornithologists and nature students all over the world. They, too, dive straight into it when they come to New York.

On a hot, airless afternoon recently, we went up to the Park to take what may be our last look at the Ramble. The place has been marked for "improvement" by the Commissioner of Parks (Robert Moses), who plans to unscramble the Ramble, comb its hair, and build a recreation center there for old people—shuffleboard, croquet, television, lawns, umbrella tables, horseshoe pitching, the works. This strikes us as an unnecessary blunder.

Almost any place in Central Park would lend itself to shuffleboard, but the Ramble has lent itself to more than two hundred species of travelling birds. It is truly a fabulous little coppice.

On a still summer's day, it is nothing to write home about; we found it populated by grackles, house sparrows, rats, gray squirrels, lovers and one gnarled old editorial writer creeping sadly about. But on a morning in May the Ramble is alive with bright song and shy singers. (Soon it will ring with early TV commercials and the click of quoits.)

The conversion of the Ramble from a wild place to a civilized place, from an amazing successful bird cover in the heart of the city to a gaming court, raises a fundamental question in Park administration. City parks are queer places at best; they must provide a green escape from stone and steel, and they must also provide amusement for the escapees—everything from zoos to swings, from ball fields to band shells. The original design of Central Park emphasized nature. The temptation has been to encroach more and more on the jungle. And the temptation grows stronger as more and more citizens die and leave money for memorial structures. It seems to us that if it's not too late, Mr. Moses should reconsider the matter of the Ramble and find another site for oldsters and their fun making.

Robert Cushman Murphy, birdman emeritus of the American Museum of Natural History, wrote a letter to the *Times* not long ago on this subject. Mr. Murphy made the following statement: "There is probably no equal area of open countryside that can match the urban-bounded Ramble with respect to the concentration of birds that funnels down from the sky just before daybreaks of spring." Think of it! This miniscule Manhattan wildwood taking first place in the daybreaks of spring! It is no trick to outfit a public park for our winter mornings, our fall afternoons, our summer evenings. But the daybreaks of spring—what will substitute for the Ramble when that happy circumstance is tossed away.

—E. B. White and C. Stevens

"TALK OF THE TOWN" OCTOBER 8, 1955

Robert Moses, we see by the papers, is going ahead with his plan to fix up the Ramble in Central Park for the use of old people and migratory birds. The old people will sing and caper, and the more adventurous of the birds will play shuffleboard. A fence will surround the whole. This is all well and good (we had an idea Moses would clean up those bulrushes), but there were a couple of very peculiar phrases in the *Times* version of the story.

"Serious bird-watchers," Mr. Moses is quoted as saying, "will be allowed into the area in the early-morning hours during the migration season." And all "orderly" adults will be admitted during the day. Well, how d'ya like that? Serious bird-watchers. Orderly adults. Moses may have to reckon with us yet in this business. We are an old fence climber from away back (got into Gramercy Park one moonlit night many years ago with a girl who wanted to assassinate Edwin Booth).

We also watch birds, both in our serious moments and in our times of utter caprice. Furthermore, bird watching sometimes brings out the disorderly streak in us and we raise hell in the Park and throw our field glasses.

So a bird watcher has to be serious! The *Times* reporter, who had been up and cased the Ramble, said he saw only pigeons and stuff; he said "this isn't the migrating season." Maybe it isn't, but if he wants to see a hermit thrush, a white-throated sparrow, and two confusing fall warblers within fifty yards of the Third Avenue saloon to which we repair when we feel the old disorderliness coming on, we'll be glad to show him the sights.

—E. B. White

On December 1, 1955, *The New York Times* reported: "The bird watchers have won the Battle of the Ramble." Mr. Moses quickly took the initiative and announced a major rehabilitation of the Ramble, with its essential nature to be unchanged, and a year later a *Times* headline announced "Moses' Men Are Restoring Bird Sanctuary to Its Pristine Wild Charm."

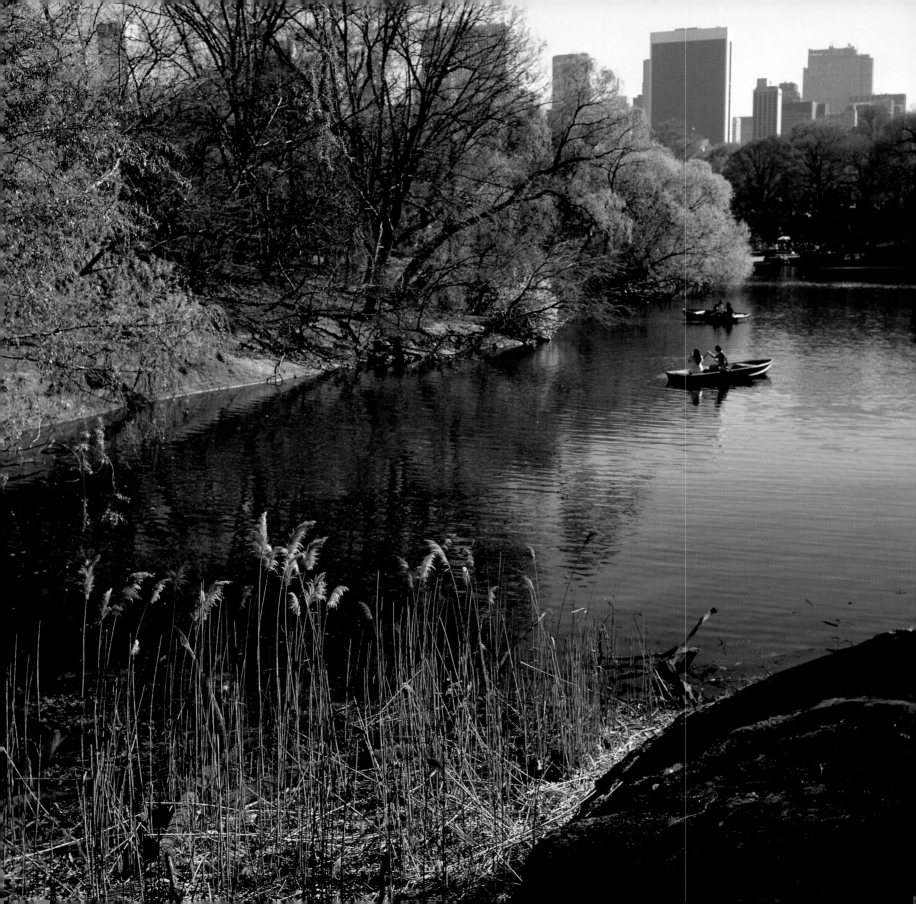

EAST

The Point, Hackberry Hill, Balance Rock, the Spring

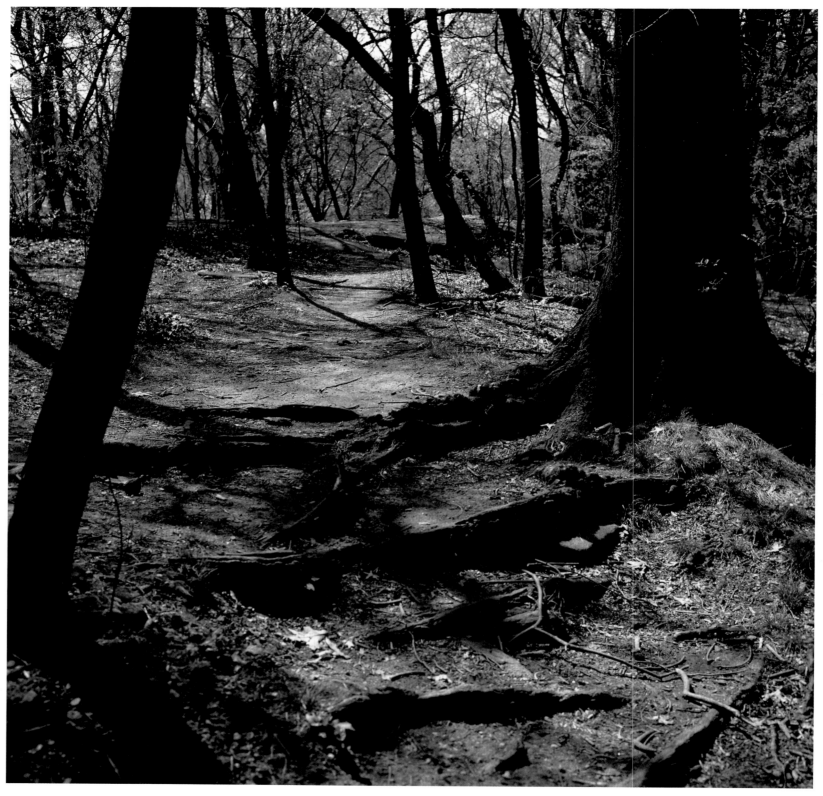

A path on the Point.

THE PICTURESQUELY ROMANTIC RAMBLE

Nineteenth-century American Romanticism took several forms: the Transcendentalism of Ralph Waldo Emerson, the poetry of William Cullen Bryant, the dramatic paintings of nature by the members of the Hudson River School, and the landscape designs of Frederick Law Olmsted and Calvert Vaux. As a pervasive cultural ethos and aesthetic, its principal tenets were a belief in the power of wild, untamed nature to foster notions of the Sublime; the capability of serene, spacious meadows and rural views to engender a response to the Beautiful; and the ability of rustic woodlands to serve as representations of the Picturesque.

While contact with the Sublime was for the most part limited to excursions from the city, the experience of passing through alternating passages of Beautiful and Picturesque scenery was the governing principle the designers of Central Park employed. And within the park, the Ramble is their romantically Picturesque masterpiece. The Ramble, like the rest of the park, is an entirely man-made landscape. While elsewhere this may not come as a surprise, in the Ramble, with its meandering brook, bosky slopes, and bold outcrops of Manhattan schist, it certainly does. Here Olmsted and Vaux's simulation of wild nature is a Picturesque tour de force, one that verges on the essence of the Romantic.

In addition to its belief in nature as a spiritual inspiration, Romanticism is imbued with notions of medievalism, mystery, and rusticity. The Belvedere—Vaux's Victorian Gothic castle crowning Vista Rock—epitomizes the Romantic in architecture; the Ramble's meandering pathways have a mysterious circuitousness that makes the experience of feeling temporarily lost in a forest a form of Romantic surprise; and the bridges and gazebo constructed of tree branches give rustic touches to a scene that one reads as Romantic grace notes. Add the plethora of migrating birds and the Central Park Conservancy's sensitive plantings of native shrubs and wildflowers, and you have a unique park experience, one that provides delightful surprises no matter how many times you go there.

—Elizabeth Barlow Rogers
Founding president of the Central Park Conservancy (1980–95) and the Foundation for
Landscape Studies (2005–present) and author of *Rebuilding Central Park: A Management and Restoration Plan*; *Landscape Design, a Cultural and Architectural History*; and *Romantic Gardens: Nature, Art, and Landscape Design*.

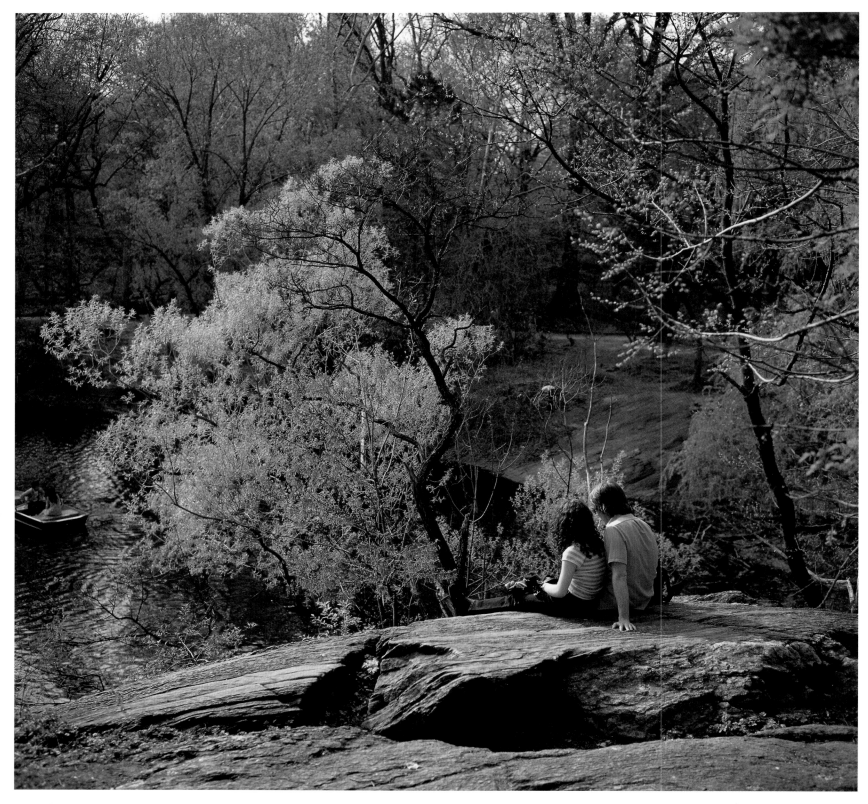

From the northwest corner of the Point looking toward the Oven and Willow Rock: willows leafing out in early spring.

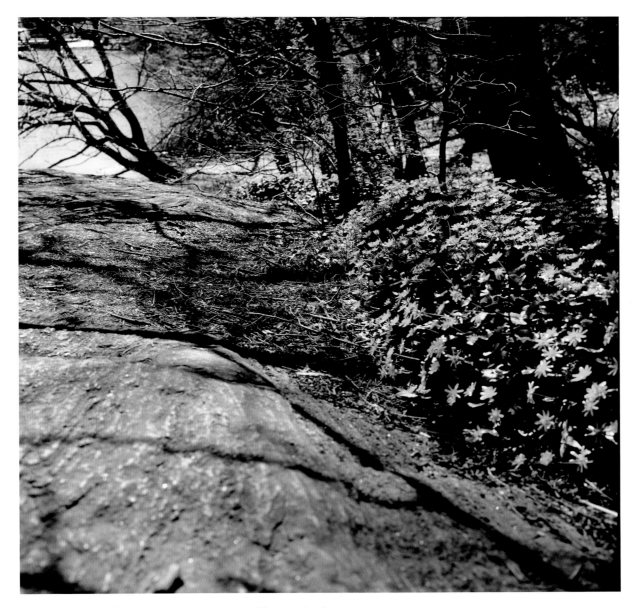

On the east side of the Point: a spring carpet of lesser celandine
next to glacially polished Manhattan schist.

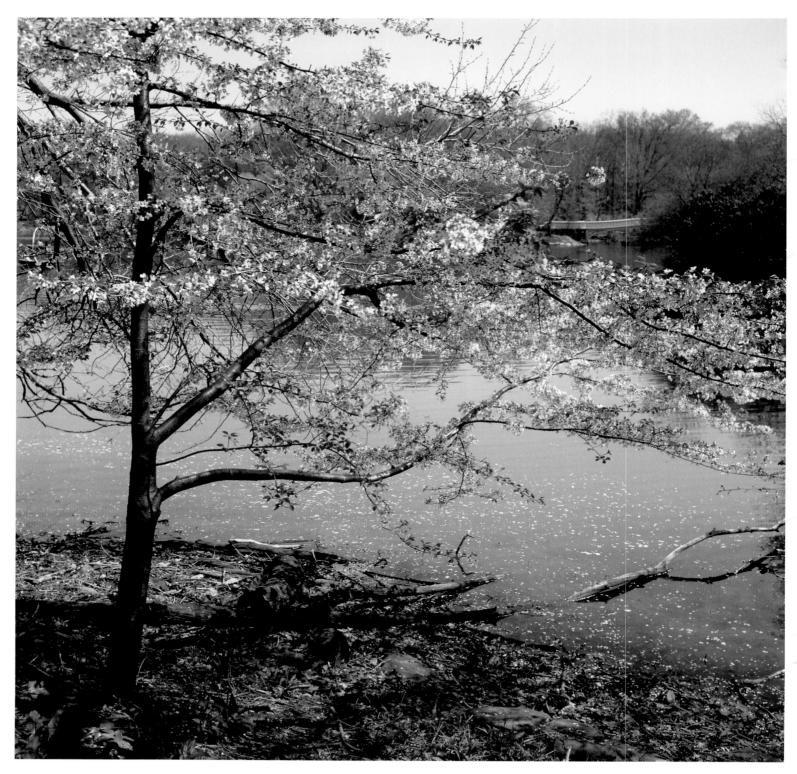

*Early spring: a blossoming cherry tree on the Point, petals falling
on a becalmed Lake, and the Bow Bridge in the distance.*

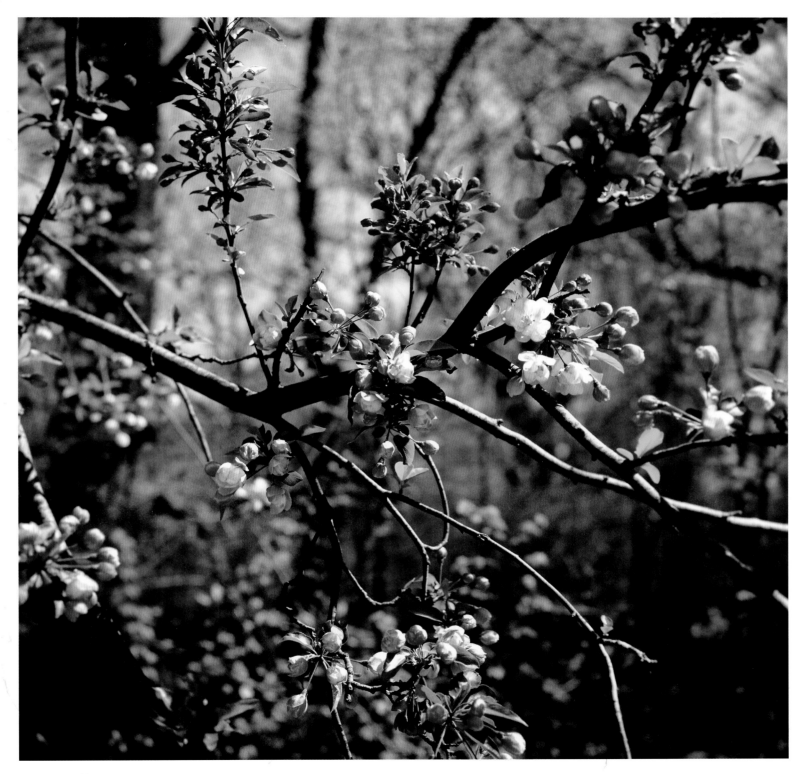

Crab apple blossoms.

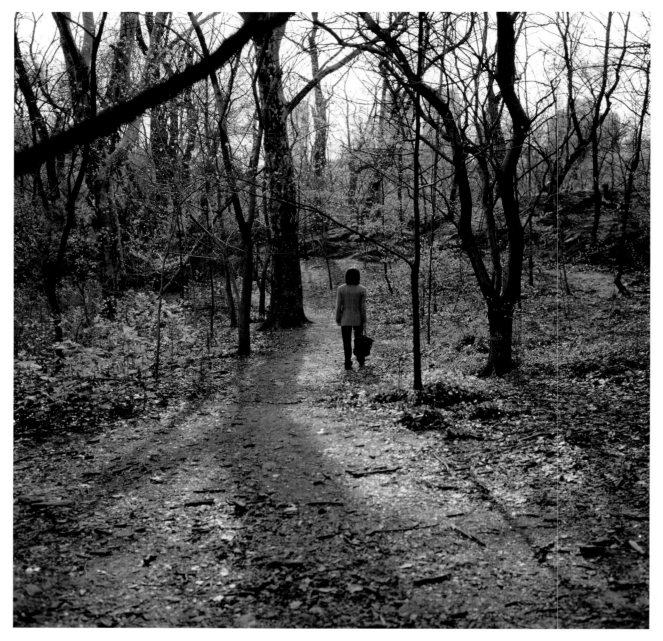

A path north of the Point.

24 🌿 EAST

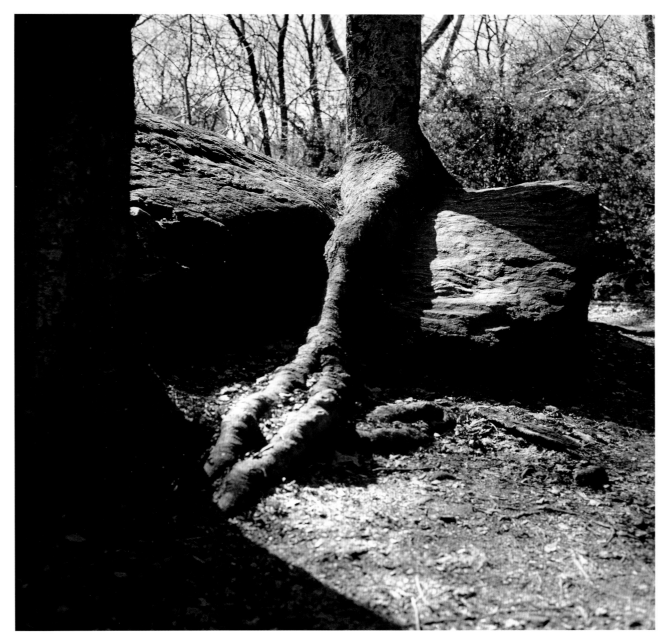

A hackberry tree clutches a rocky outcrop.

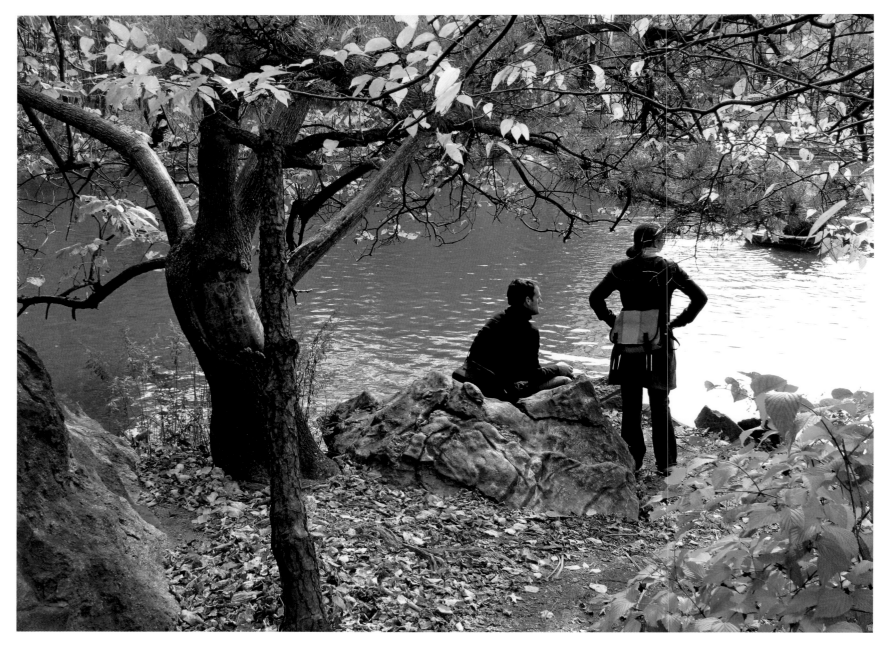

At the southern tip of the Point.

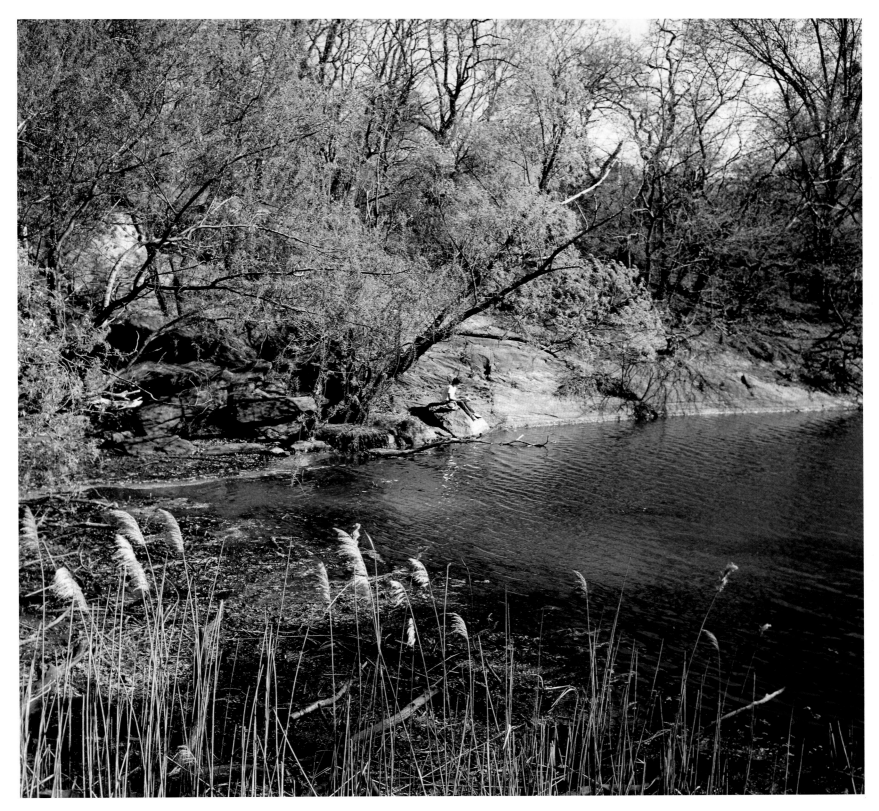

In earliest spring: the willows on the west shore of the Point, viewed from Willow Rock.

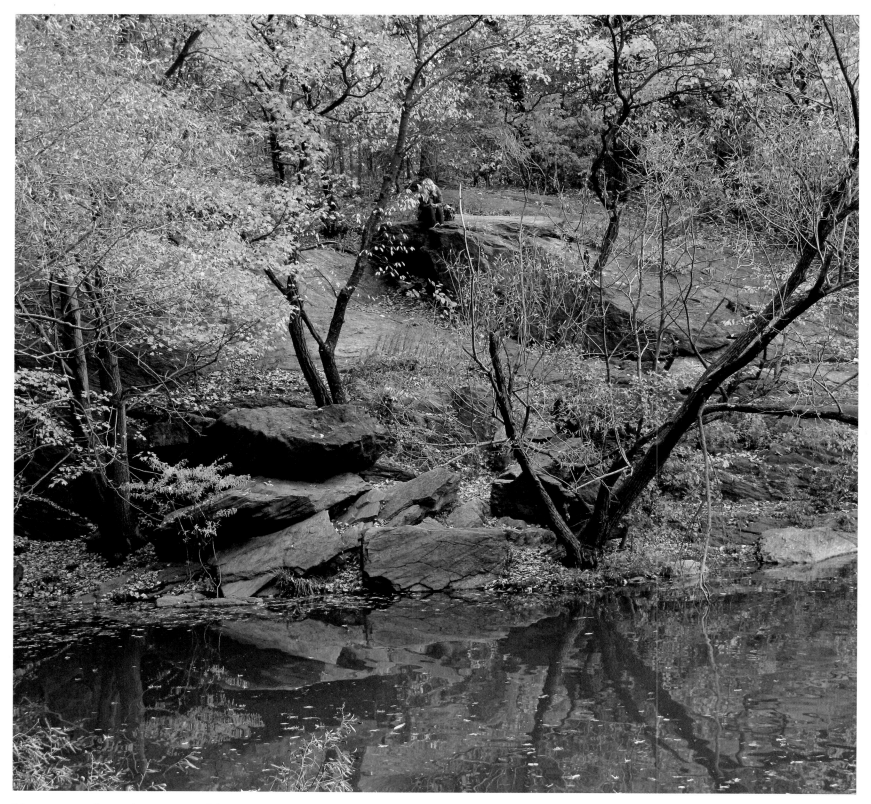

The outcrop at the northwest corner of the Point.

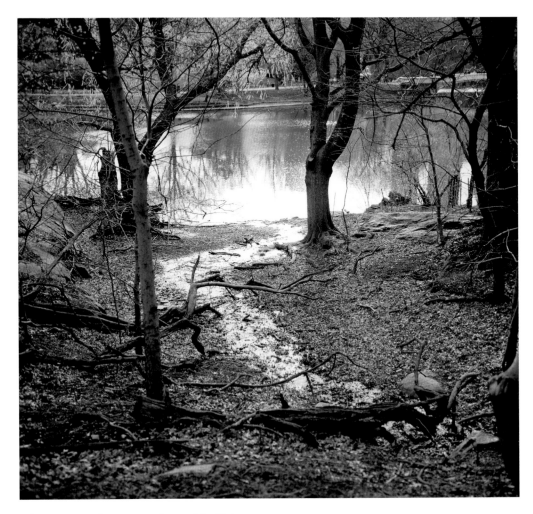

The spring on the western shore of the Point.

Walk over the crest of the rise and follow the unpaved path that leads north along the center of the Point. About twenty feet beyond the beginning of the paved path, in a gully to the west, a small spring issues from under an artistically placed rock and runs down a pebbly course to the Lake. It is better to postpone exploration if the ground is water-soaked or spongy with thaw. Even if you escape a fall, you will inevitably accelerate erosion as you slide down the unprotected slope. When the soil is dry, you can walk down the slope on the north side of the spring. If you peer under the rock, you will see that the mouth of the spring is neatly bricked. This suggests that it may once have provided drinking water or that the outlet might have been capped in order to pipe the water elsewhere.

—From *Rock Trails in Central Park* by Thomas Hanley and M. M. Graff

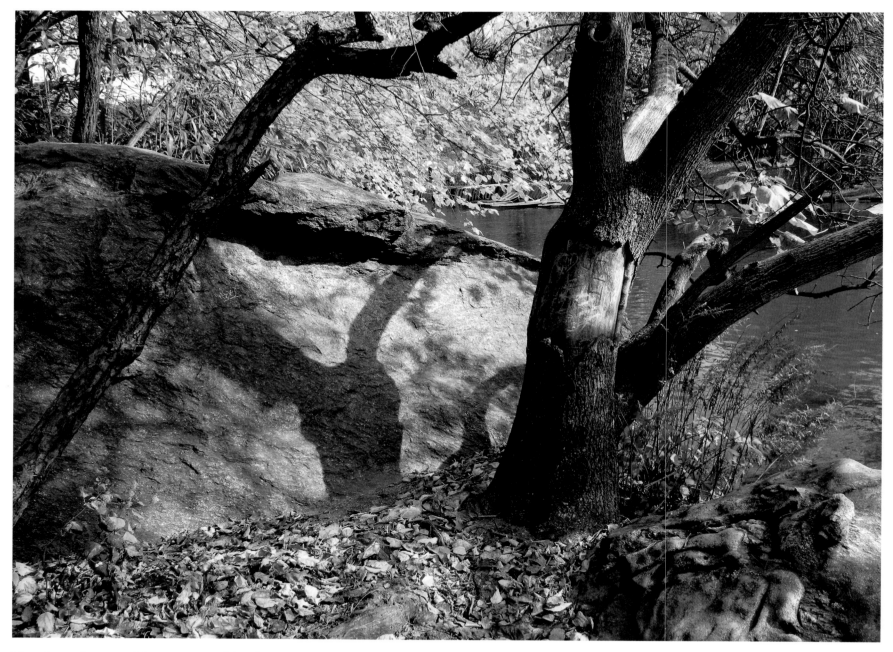

Near the southern tip of the Point: a vandalized catalpa tree,
native to the eastern United States. Behind the large rock is a stand of bamboo.

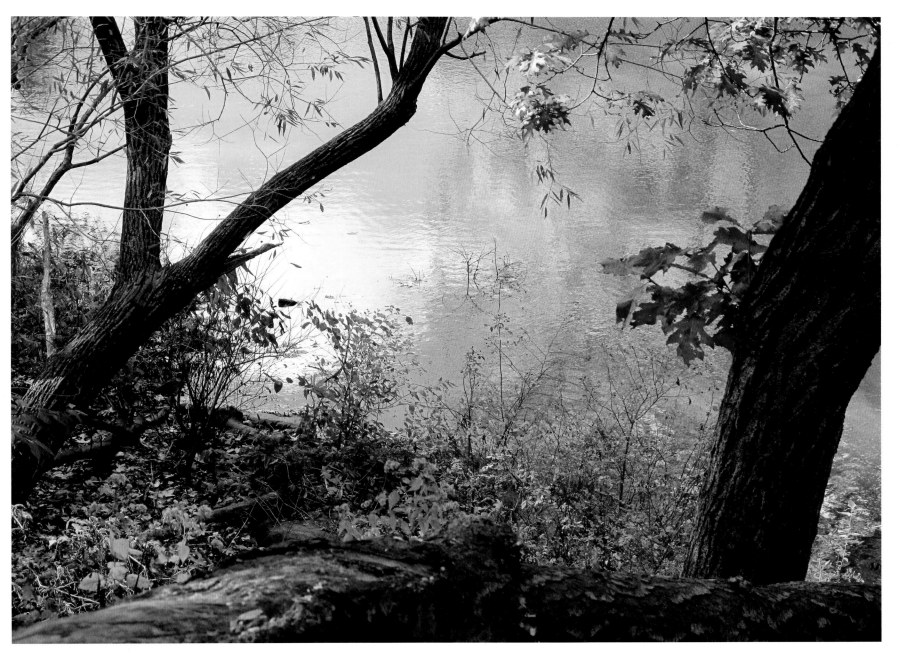

Reflections in the Lake viewed from the Point.

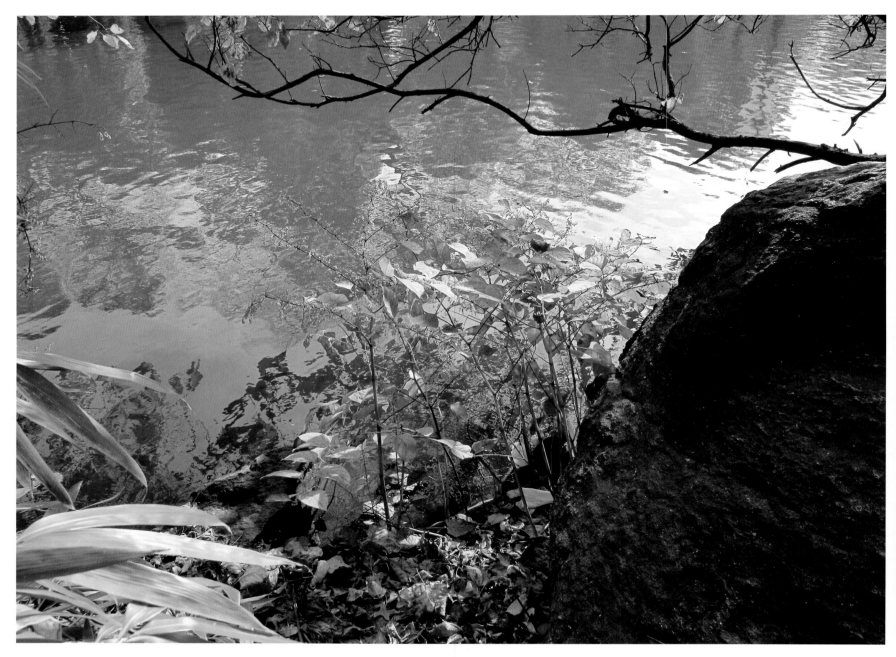

Japanese knotweed on the eastern shore of the Point.

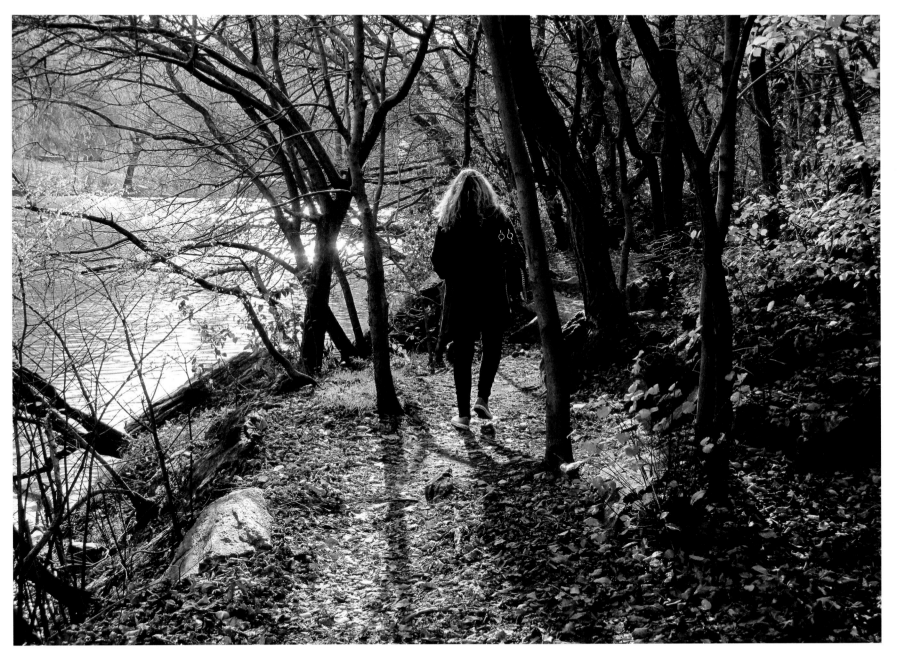

The path on the east side of the Point.

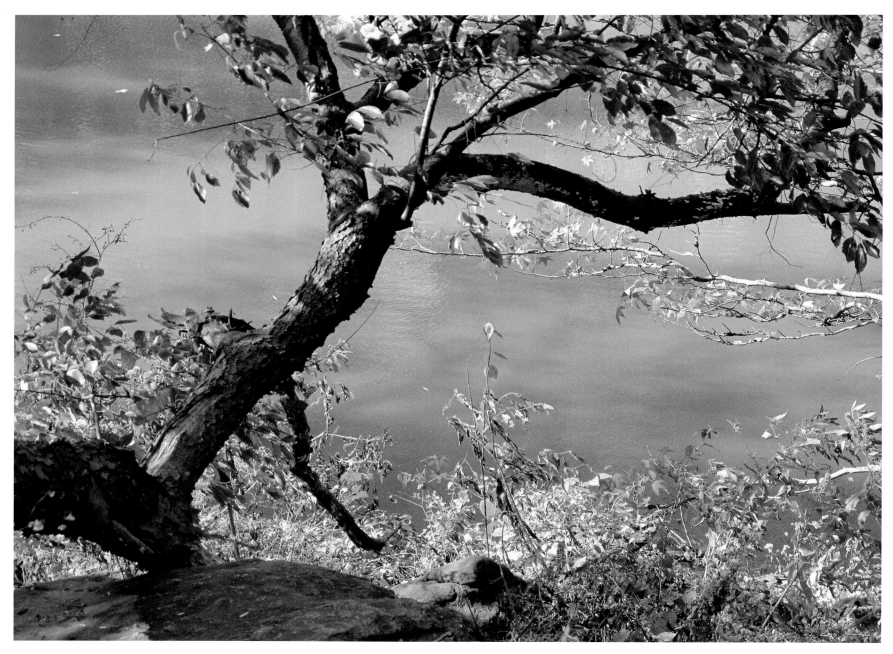

A black cherry tree on the eastern shore of the Point.

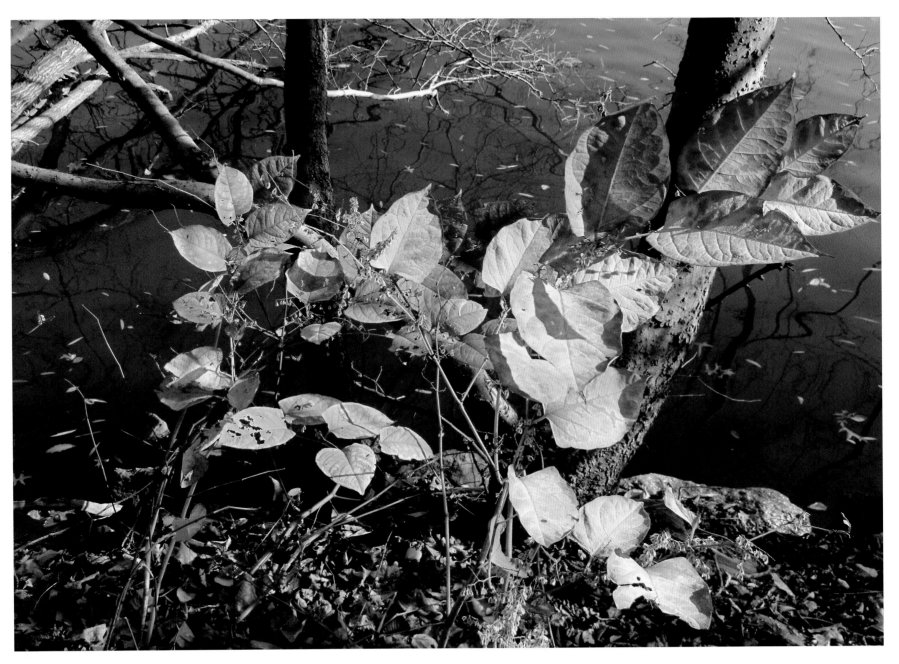

Japanese knotweed.

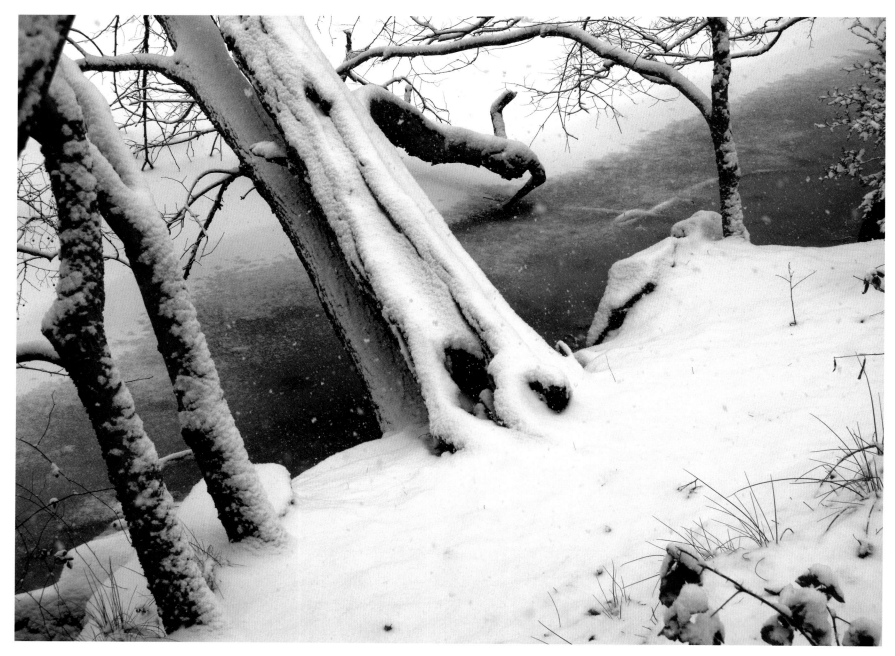

The eastern shore of the Point in a blizzard.

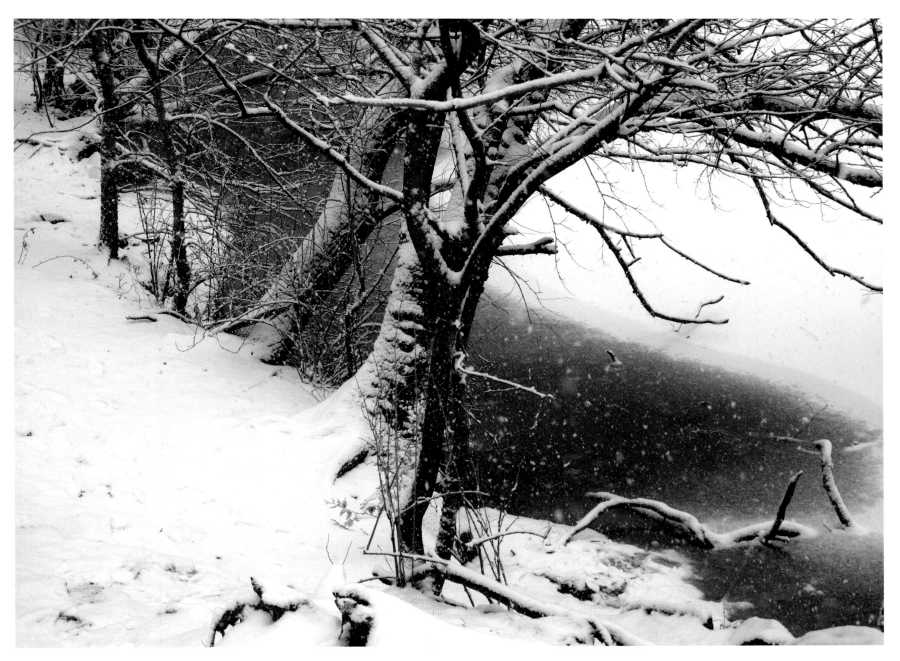

Blizzard view toward the Boathouse from the eastern shore of the Point.

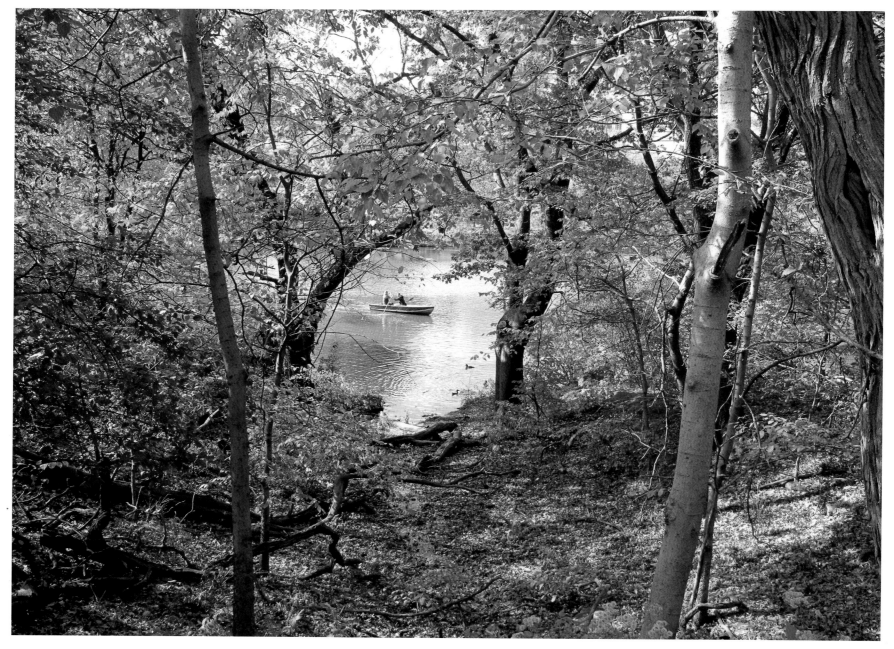

The spring on the west side of the Point.

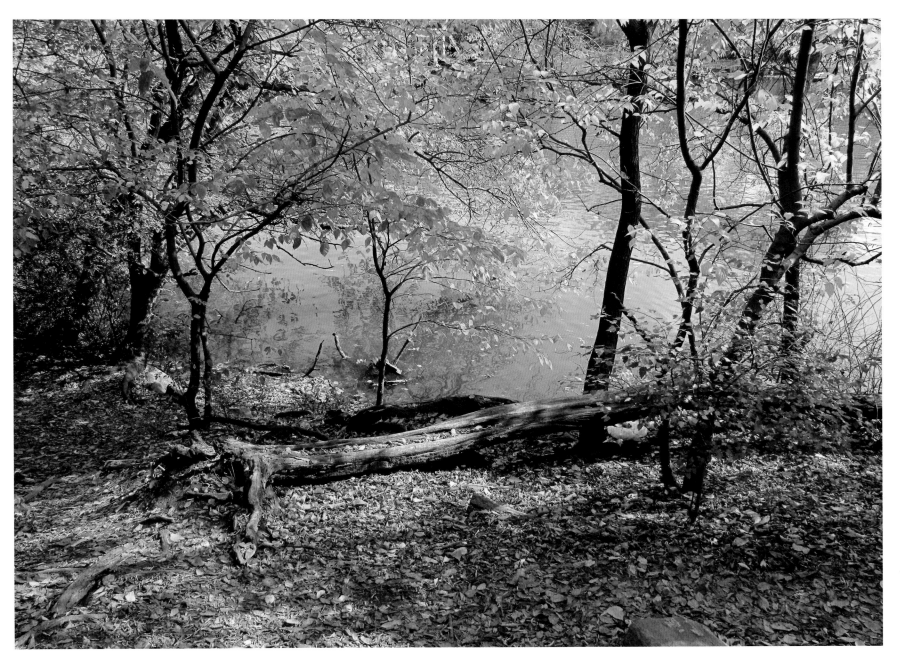

The east side of the Point.

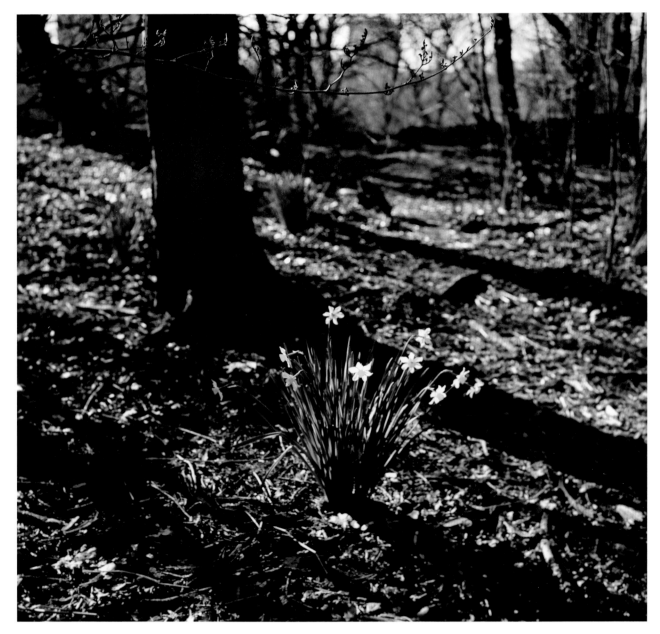

Daffodils in the woods above the Lake.

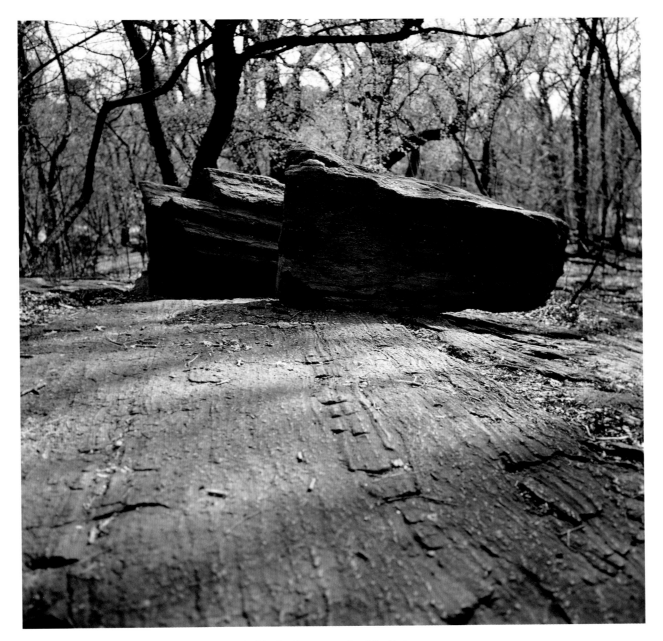

Boulder drop outs from the glacier on polished bedrock just north of the Point.

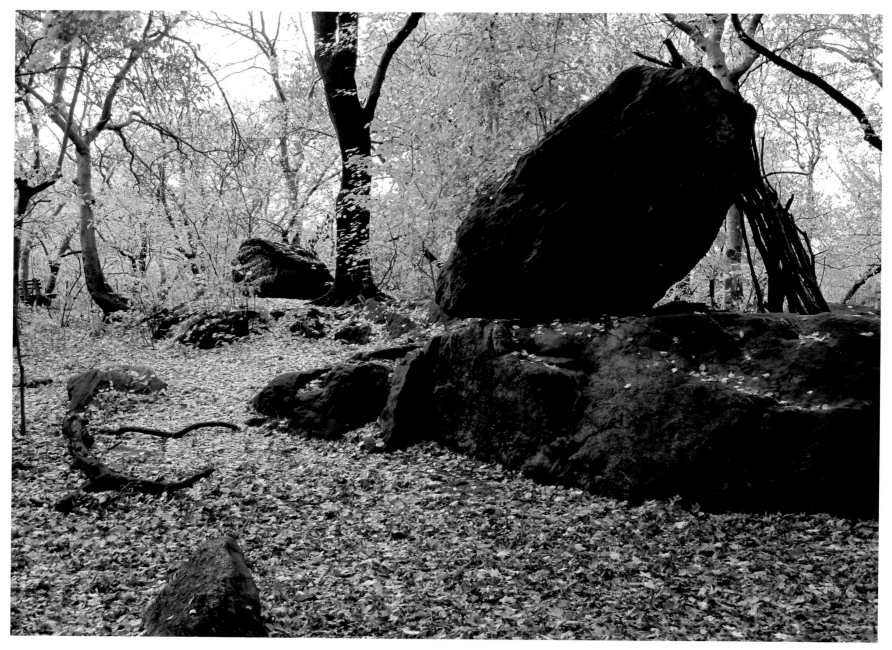

Balance Rock.

Life imitates nature.

Strolling on Hackberry Hill.

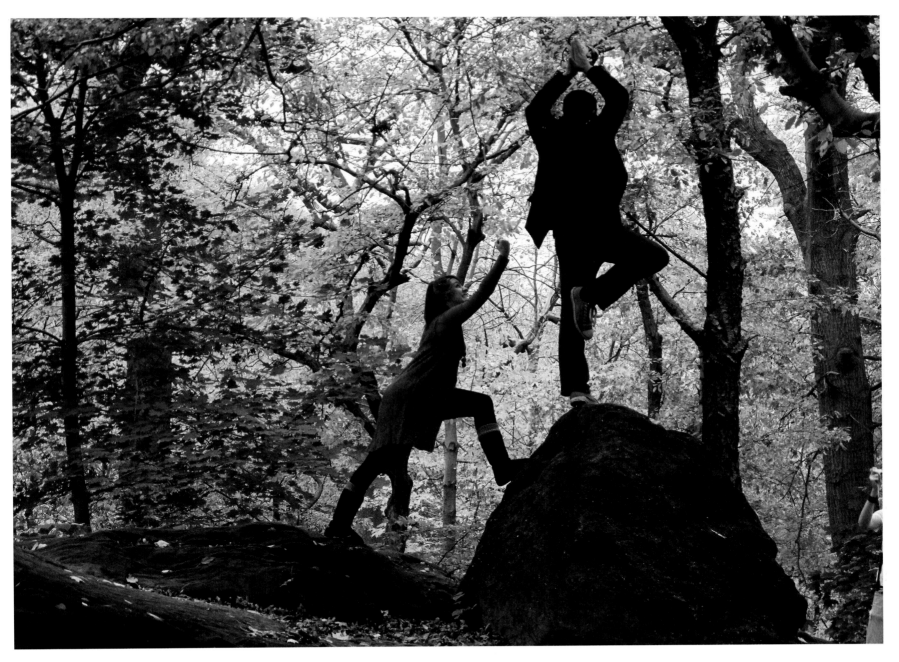

On Hackberry Hill.

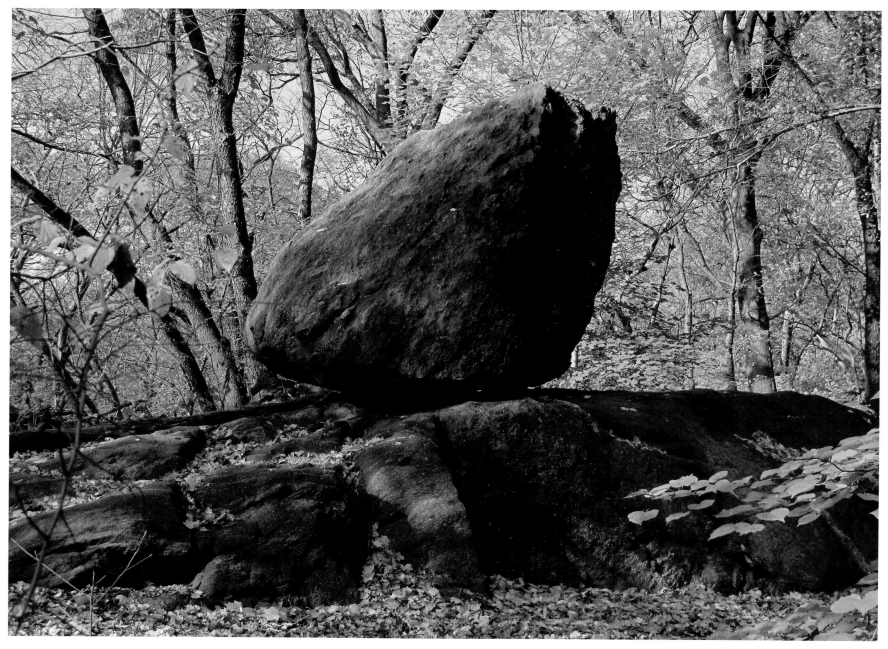

Balance Rock.

A trail north of the Point.

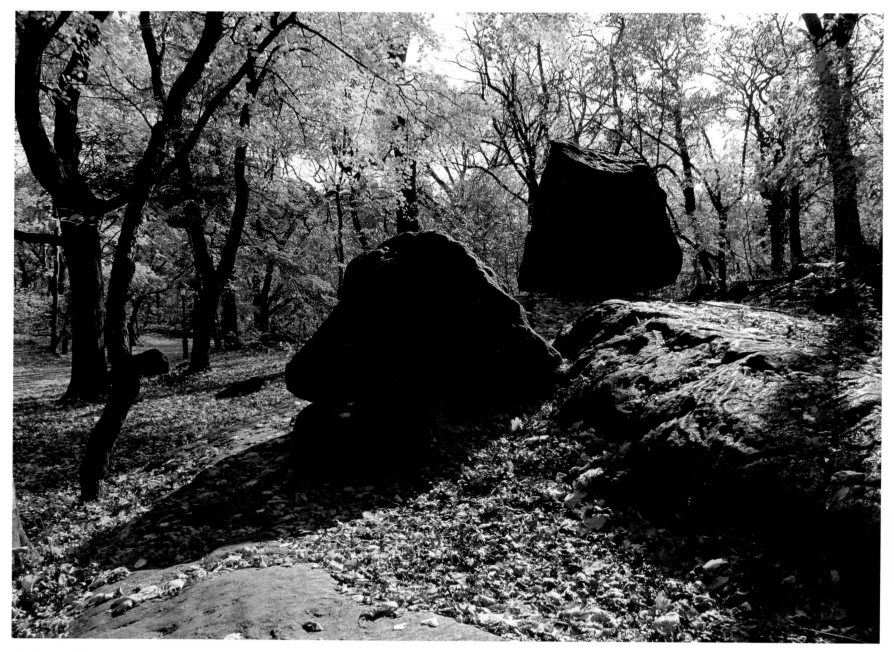

Hackberry Hill in autumn.

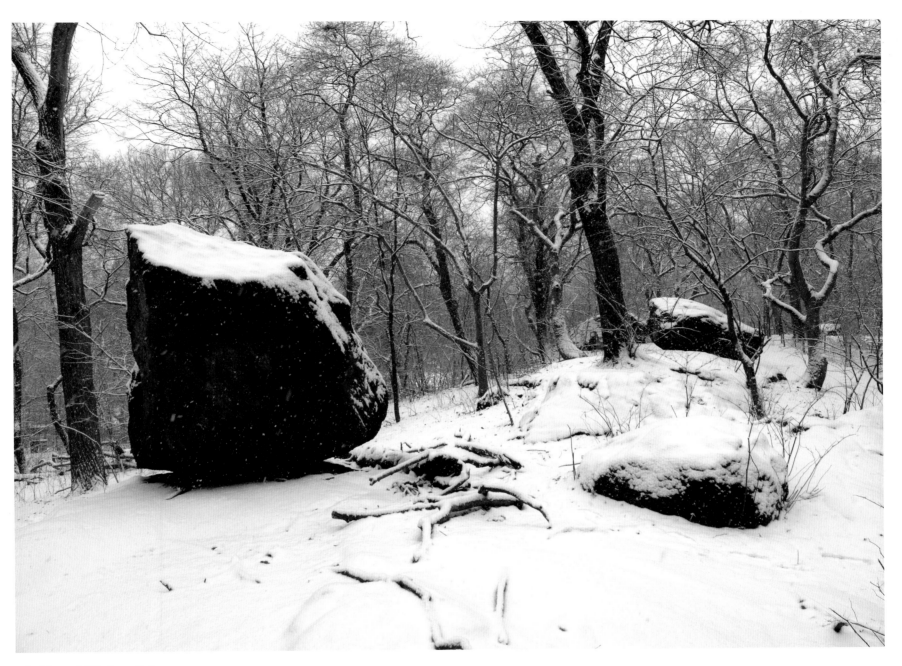

Hackberry Hill after a light snow.

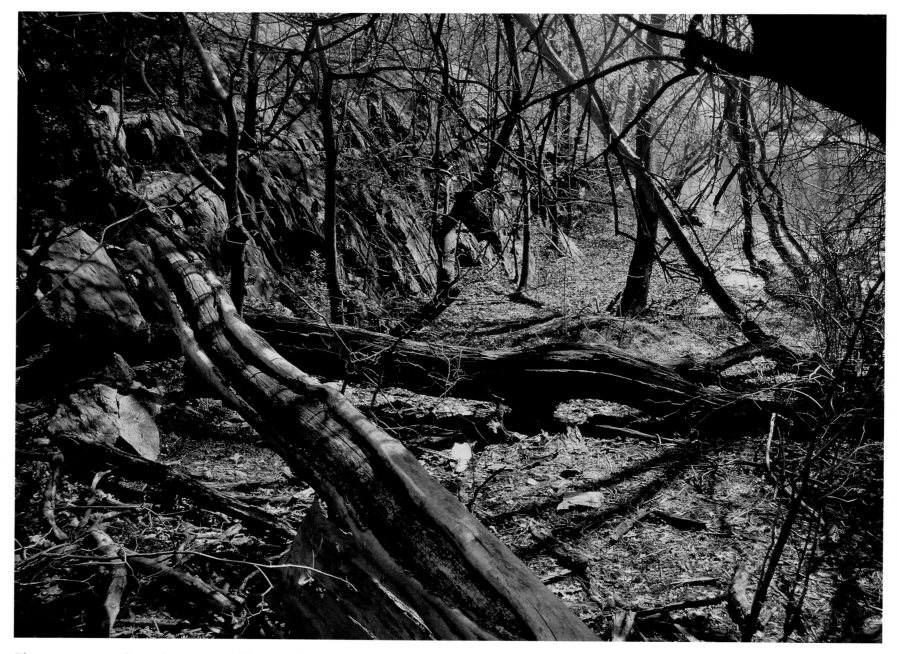

The swampy area at the northwest corner of the Point, showing the mysterious "gutter."

About halfway down the rock face is a gutter, chiseled with great exactitude for an inscrutable purpose. It is a matter of record that Olmsted despised naked rocks. He wrote to his head gardener, Ignaz Pilat, that nothing displeased and disappointed him more than the bare rocks on the north shore of the lake and around the cave, and he urged Pilat to blast holes if necessary to get vines started growing over them. By no standards, however, would this shallow, straight-line trench make a congenial or naturalistic container for plants. In any case, there are natural crevices in the outcrop which could have been enlarged with far less effort and greater effectiveness. The proximity of gutter and spring suggest a connection. Was the water piped to flow along the channel, perhaps overflowing to encourage the growth of ferns and mosses on the cliff? Did it run on to create a tiny waterfall at the north end of the cove? A check with a Brunton compass showed that the gutter slopes uphill from the spring, thus disposing of an appealing hypothesis. The problem appears impossible to solve from evidence remaining on the site. Anyone doing research on the park's history is urged to keep an eye out for an explanation. Meanwhile, any plausible guesses are welcome. About midpoint on the outcrop, the gutter reverses its pitch and slants downward towards the north. In order to flow along both sides of the trough, the source of water must have been at the peak where the two sections meet. Seepage through the rocks is considerable, though apt to go unnoticed except in winter when it builds up into impressive mounds and columns of ice. However, no seepage is visible near the apex of the troughs. This high point may once have held the secret but, by ill luck, it has been carried away by a rock slide, taking all clues with it.

—From *Rock Trails in Central Park* by Thomas Hanley and M. M. Graff

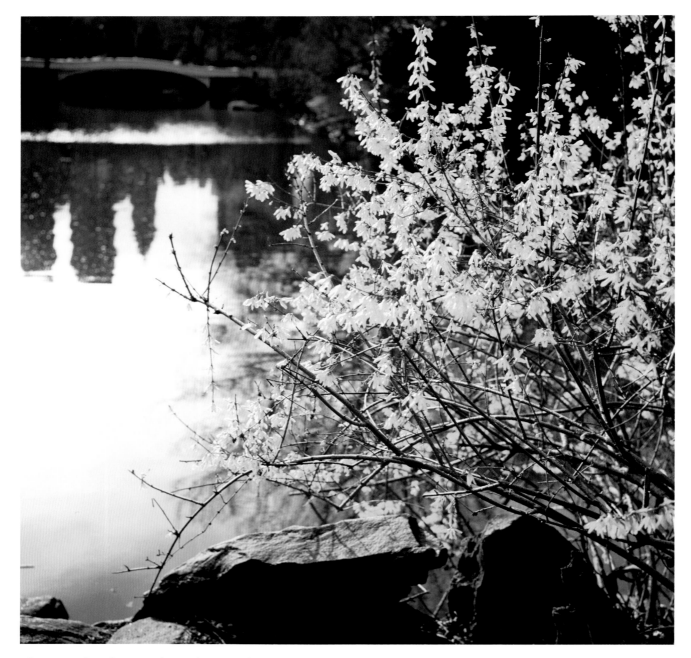

Blossoming forsythia near the southern tip of the Point, looking west toward the Bow Bridge and the buildings along Central Park West.

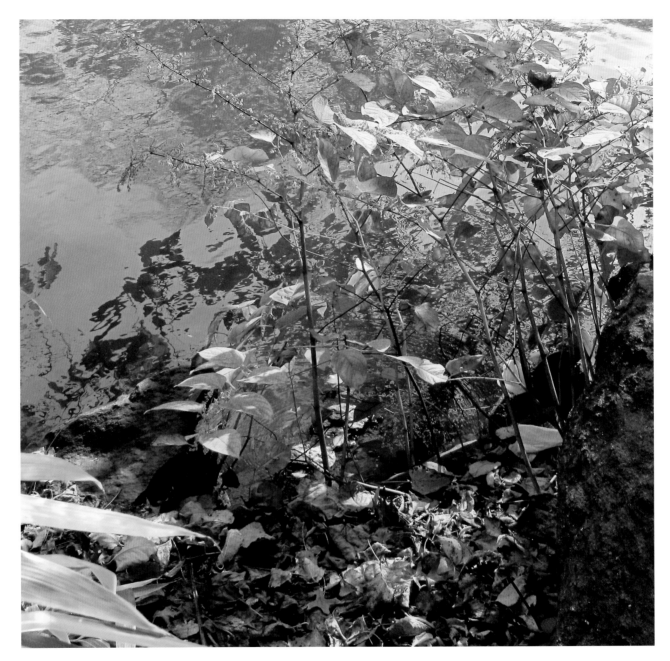

Japanese knotweed on the eastern shore of the Point.

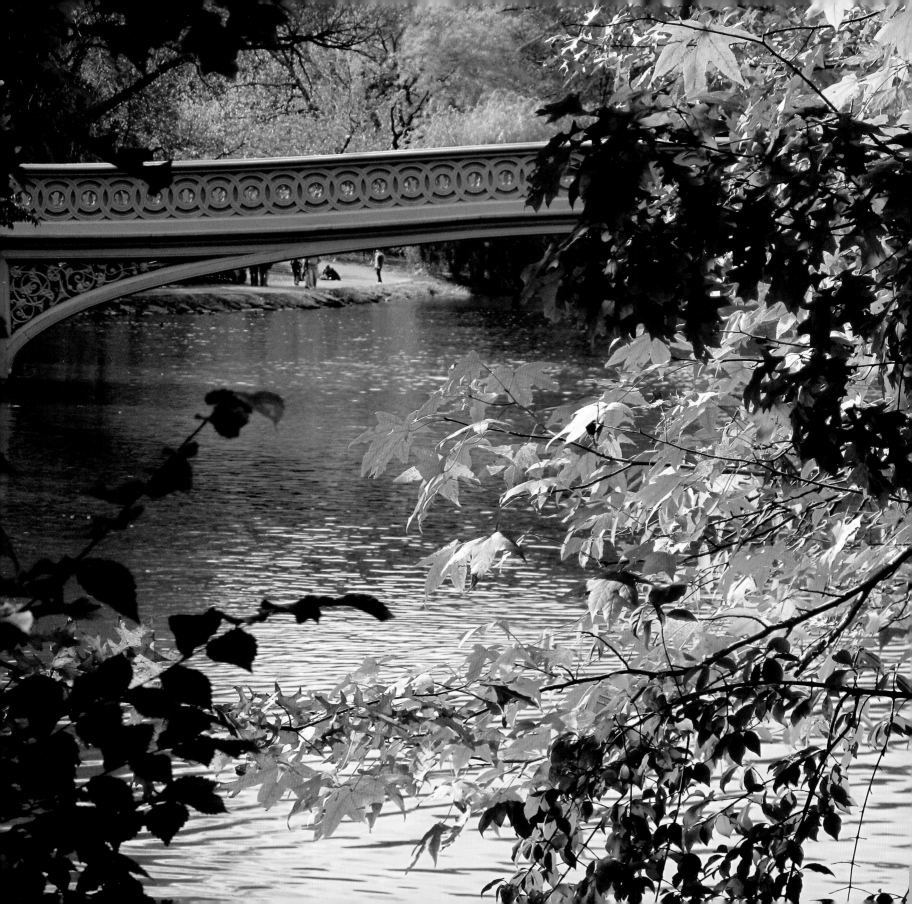

SOUTH

*The Riviera, Bow Bridge, the Oven, Willow Rock,
Warbler Rock, the Boat Landing*

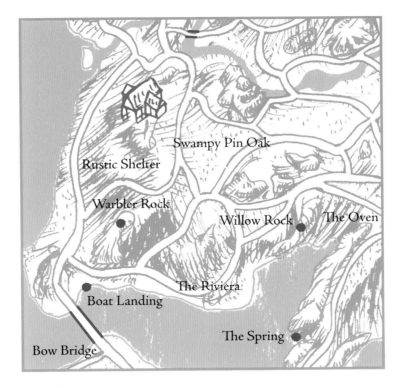

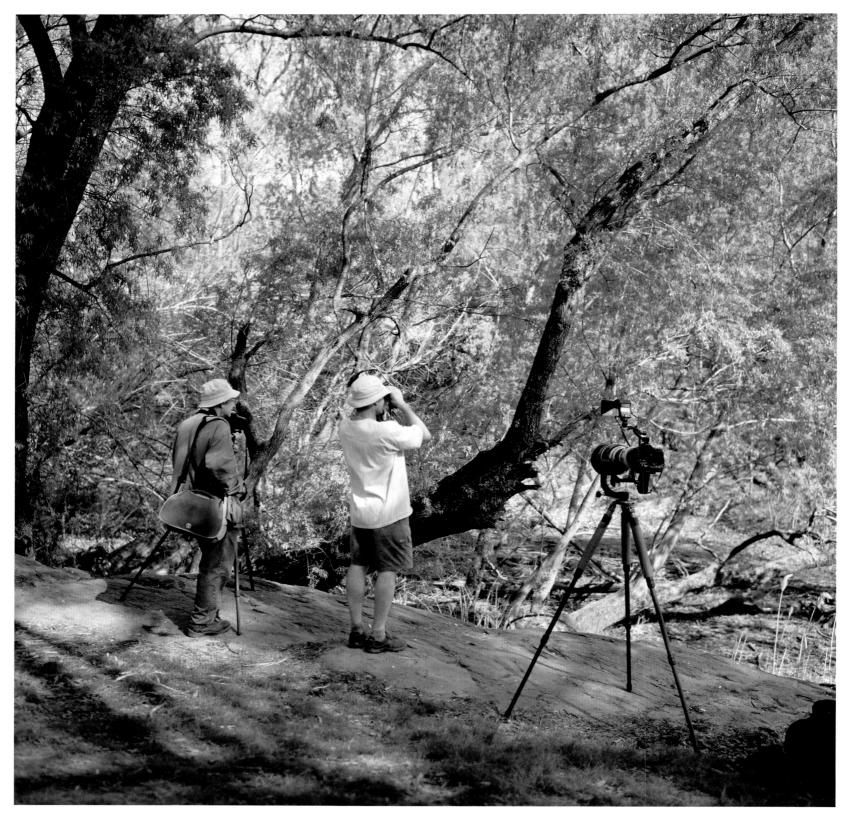

Birders on Willow Rock, looking east to the Oven.

THE BIRDS OF THE RAMBLE

When I tell people I spent three years photographing birds in New York City's Central Park, I usually get a response like, "You sure must like pigeons." While it's true there are quite a few pigeons in the park, there is also an abundance of warblers, egrets, hawks, ducks, woodpeckers, vireos, cuckoos, sandpipers, and flycatchers that visit Central Park, choosing the Ramble as their stopping point. In addition to resident species, as many as two hundred different migrants regularly pass through the park in any given year during spring and fall migration. Since its creation more than 150 years ago, the park has become a magnet for migrating neo-tropical songbirds and other species that winter in the south. More than 325 different species have been observed within the park's 840 acres over the past century, and many bird watchers consider Central Park—and more specifically the Ramble—one of the top birding spots in the United States.

This phenomenon is a happy accident of geography and nature. Central Park is located on the Atlantic Flyway, the migration route favored by more than 150 species of birds that move back and forth to their breeding grounds in the north in the spring and fall. Since most of these species migrate at night, the large dark area that is the Ramble among the light-filled concrete canyons must seem like an ideal place to find the rest and nourishment required to continue their journey. The park attracts and holds these birds because it provides a smorgasbord of food and water for these weary travelers. Some spring mornings when the winds have been steady from the southwest, hundreds of warblers seem to drop out of the sky and perch. On those happy mornings you will find bird watchers and photographers throughout the Ramble.

Beginning with the first Eastern Phoebe in mid-March and continuing through late May, a steady stream of migrating birds moves through the park. Most interesting to me are the small, brightly colored neo-tropical songbirds known as wood-warblers. I have photographed more than twenty-five different species of these tiny, colorful birds in Central Park, including such rarities as Black-throated Gray, Cape May, Prothonotary, Yellow-throated, Worm-eating, and Hooded Warblers. While less colorful in their nonbreeding plumage, these same birds stream back through the park beginning in August and continue to do so through early October heading south. There are also other migrants, including American Woodcocks, Spotted and Solitary Sandpipers, and numerous varieties of sparrows—but my heart belongs to the warblers.

In addition to migrating birds, an Audubon study confirmed that there were more than thirty species of birds breeding in Central Park. Along with the ubiquitous robin, starling, sparrow, and gracklenests, the careful observer can find House Wrens, Gray Catbirds, Downy Woodpeckers, Tufted Titmice, Warbling Vireos, Cedar Waxwings, Wood Thrush, Northern Flickers, American Kingbirds, and White-breasted Nuthatches nesting in the park. The Mallards can also be counted on to provide several broods of ducklings on just about every body of water in the park. Some of the more unusual nesters are the Green Herons that return to the Upper Lobe every year and the Eastern Screech-owls that nest in several places in the park, including the Ramble. There are usually two or three Red-tailed Hawks nesting in the park during any given year, and American Kestrels and Merlins make their nests in the buildings adjacent to the park.

Summer in the park can be a bit slow. There are, however, plenty of egrets and herons, and most of my time is spent photographing these long-legged waders and the various nesting birds. Fall brings migrating warblers back to Central Park in large numbers. Although the males have shed their bright plumage they are still fun to photograph. Ruby-throated Hummingbirds also visit the park in the fall, attracted by the many deep-throated flowering plants. These tiny birds extract nectar from the flowers with their long, thin bills and are very active feeders. It's hard to get more than two or three shots before they dart to another flower.

Winter is ideal for getting spectacular shots of hawks and owls. Since there are no leaves on the trees, these predators are relatively easy to find. Extra help is provided by Central Park's squirrels; they make a low, mew-

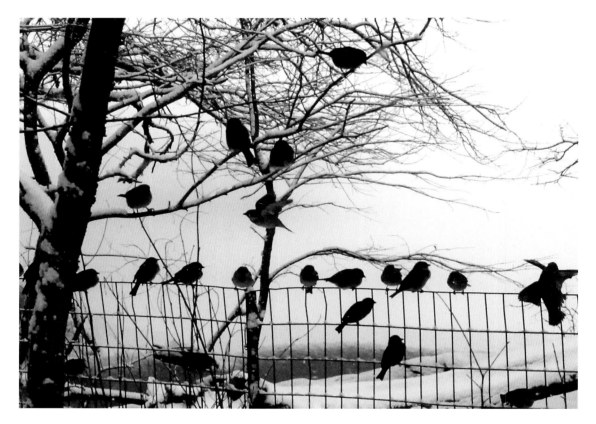

Sparrows in a blizzard.

ing sound when they spot a hawk perched in a tree. Owls are also frequent winter visitors. Long-eared Owls and Saw-whet Owls are the two most common species found in the park. Although nocturnal, they can usually be found during the day roosting high in the park's many pine trees. A Boreal Owl turned up a few years ago next to the restaurant Tavern on the Green, and Long-eared and Eastern Screech-Owls also visit from time to time.

In winter a dedicated group of birders maintains several feeders in Evodia Field in the Ramble. Hairy and Downy Woodpeckers, Fox Sparrows, Savannah Sparrows, Carolina Wrens, Common Redpolls, Black-capped Chickadees, and Tufted Titmice are frequent visitors to the feeders. The benches near the feeders are a good place to sit and wait for the hawks that are inevitably drawn to the large numbers of smaller birds feeding there. I've gotten some of my best raptor shots there.

It's not unusual to find Wood Ducks, Hooded Mergansers, Ruddy Ducks, Grebes, and other freshwater wildfowl on the Meer or Central Park Lake in winter. Several years ago, during a cold snap, the open water on the Lake was reduced to a small area, and all the waterfowl were concentrated very close to shore. Although wary, they came much closer to humans than they would in the wild. By lying on the ground I was able to get some very nice eye-level shots of Wood Ducks and Hooded Mergansers. Often brightly colored male Wood Ducks visit Central Park Lake and stay for the winter.

There are always a few rare birds that show up in the park. The Tavern on the Green Boreal Owl was a highlight, although a vagrant Black-throated Gray Warbler also made a brief appearance (far from its home out West) and a Western Tanager (another western vagrant) hung around most of the winter two years ago. And there are often juvenile Red-headed Woodpeckers that winter in the park. One late November several years ago, five Long-eared Owls perched in a tree about ten feet above an active walkway near Bow Bridge in the Ramble. They stayed for several weeks and attracted large crowds.

The park even has its own celebrity bird, Pale Male, so named because of his very pale coloration. This Red-tailed Hawk made headlines when he and his mate were summarily evicted from their lofty Fifth Avenue nest by a heartless co-op board. The hawks had nested above a window on the seventh floor of the same building for the past thirteen years. With the help of Mary Tyler Moore (a resident of the building) and crowds of vocal protesters, Pale Male's nest was returned. What's remarkable about these Red-tails is that they built their nest on a building in the first place. According to experts, Red-tails don't normally do that.

Although Central Park is completely man-made, it was designed to be part wilderness, and these wild areas, most notably the Ramble, are ideal for wildlife photography. An abundance of food and water and a happy fluke of geography combine to make Central Park a wildlife photographer's must-visit venue. I don't think there's been a day when I didn't return home from the park with at least one "keeper." But I'd rather keep this our little secret; so if you visit the park and agree with me, please don't tell anyone else.

—Cal Vornberger
Wildlife photographer and author of the book, *Birds of Central Park*

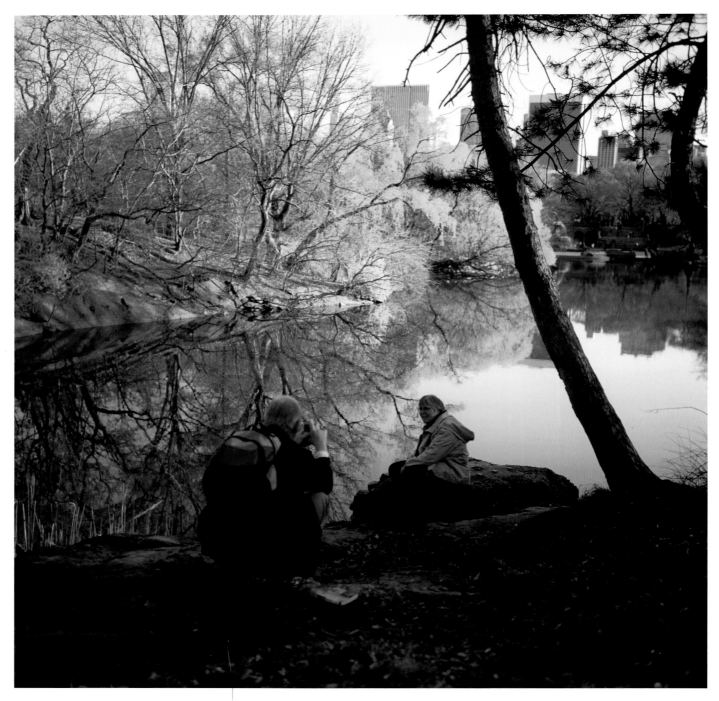

Earliest spring, first leaves. On Willow Rock at the Oven, looking southeast toward the Point.

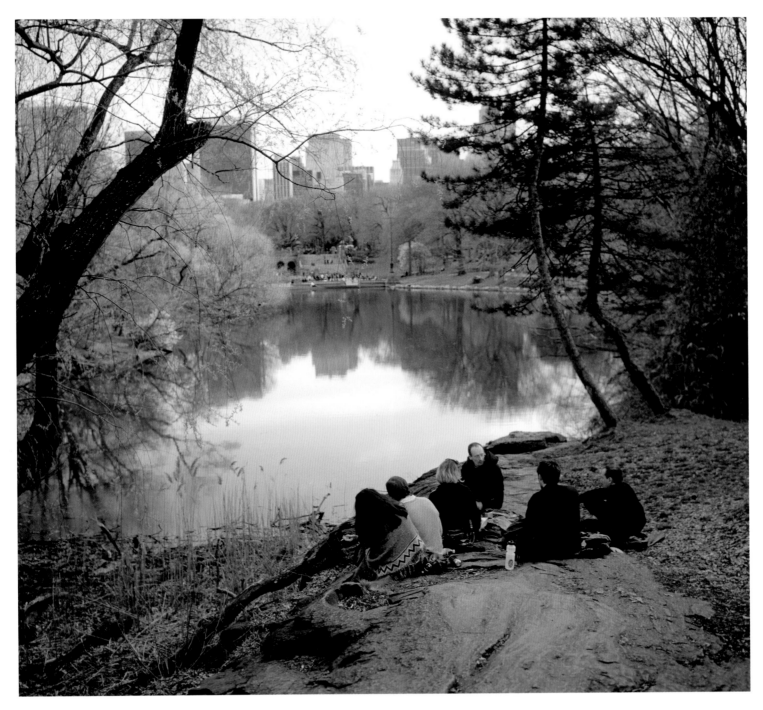

Willow Rock.

The Oven, looking south toward the Lake. Earliest spring: willow branches leafing out over a hackberry trunk.

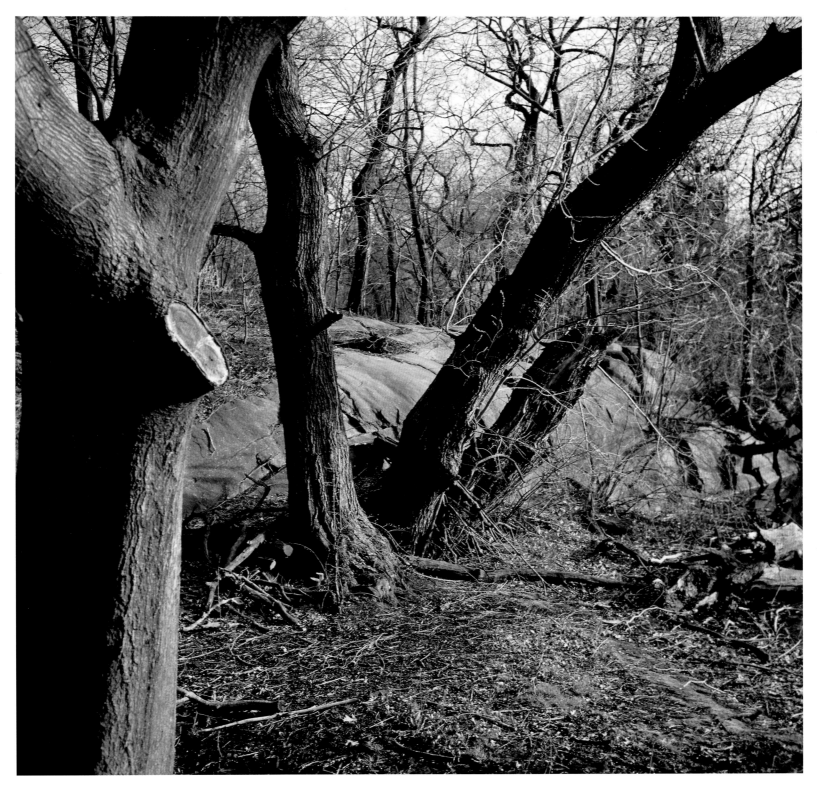

A grove of willow trees.

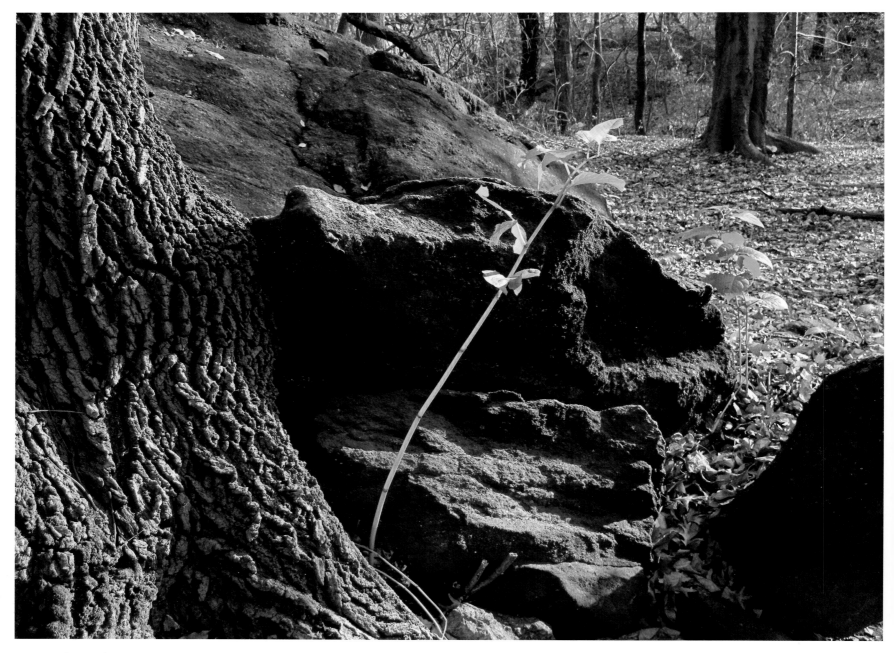

A green shoot in late November.

64 🌿 SOUTH

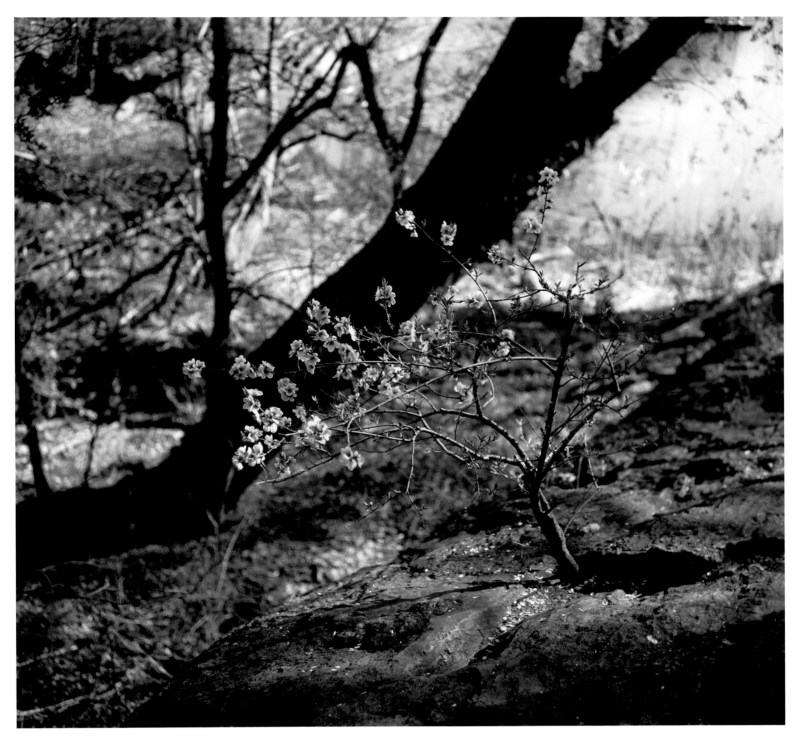

A peach tree growing from Willow Rock at the Oven, with the trunk of a willow behind.

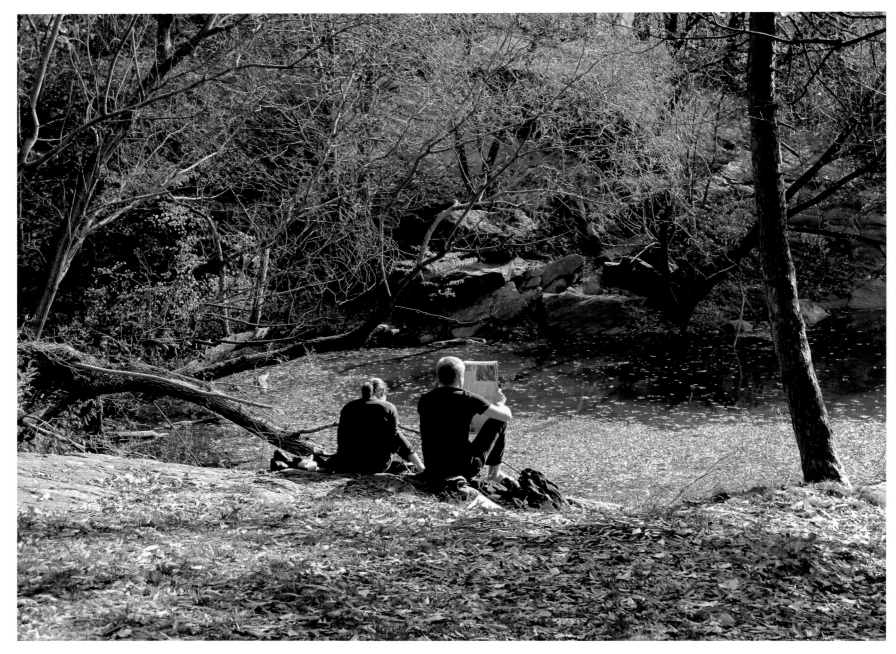

The Oven, looking east from Willow Rock.

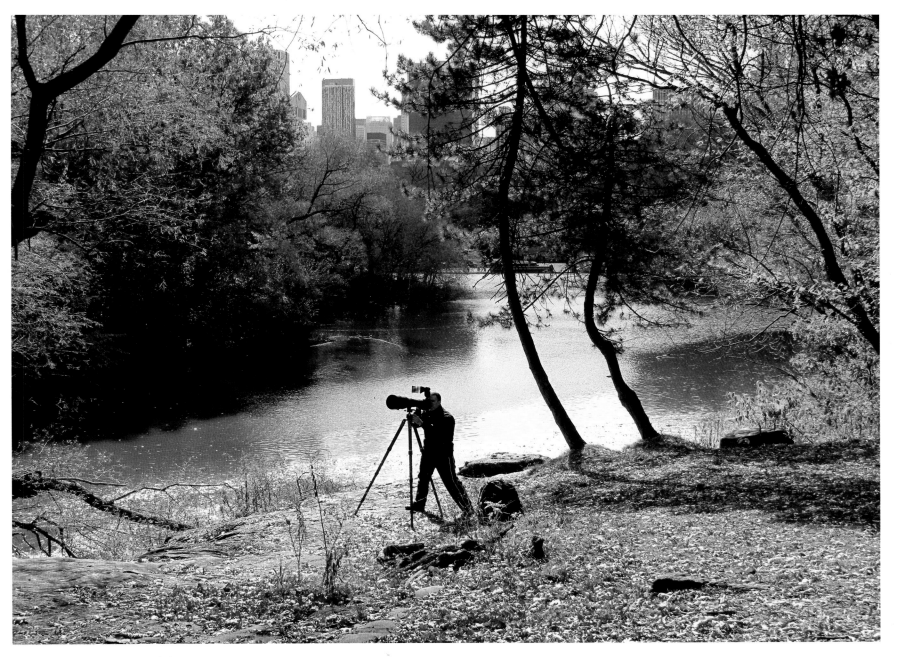

Birding at Willow Rock and the Oven.

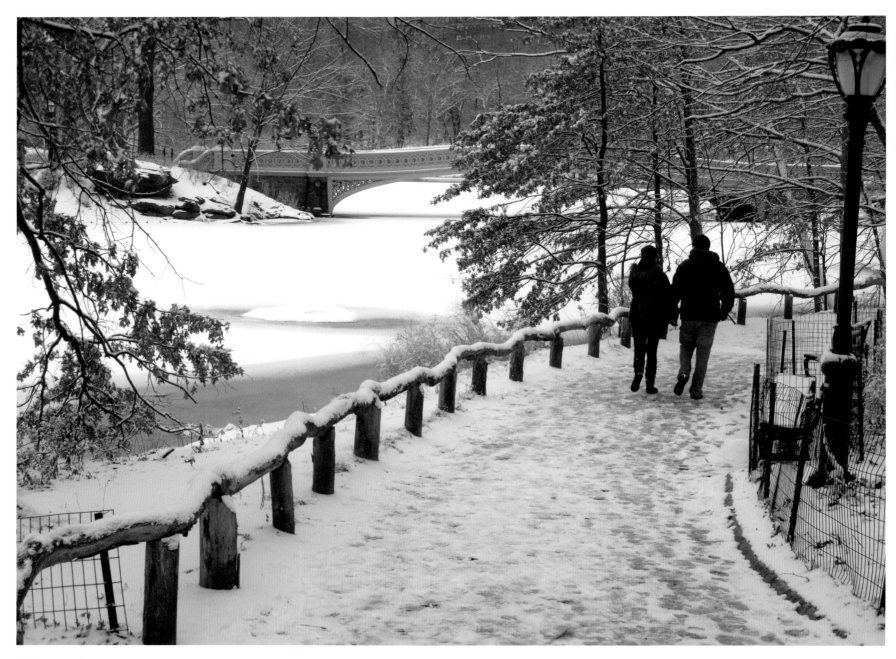

Winter on the Riviera.

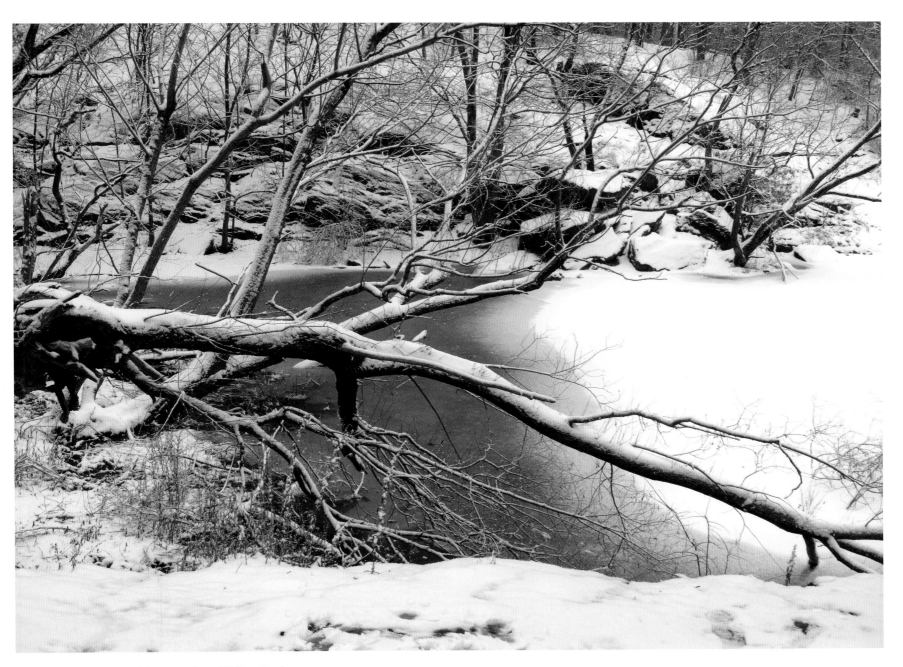

The northwest corner of the Point from Willow Rock.

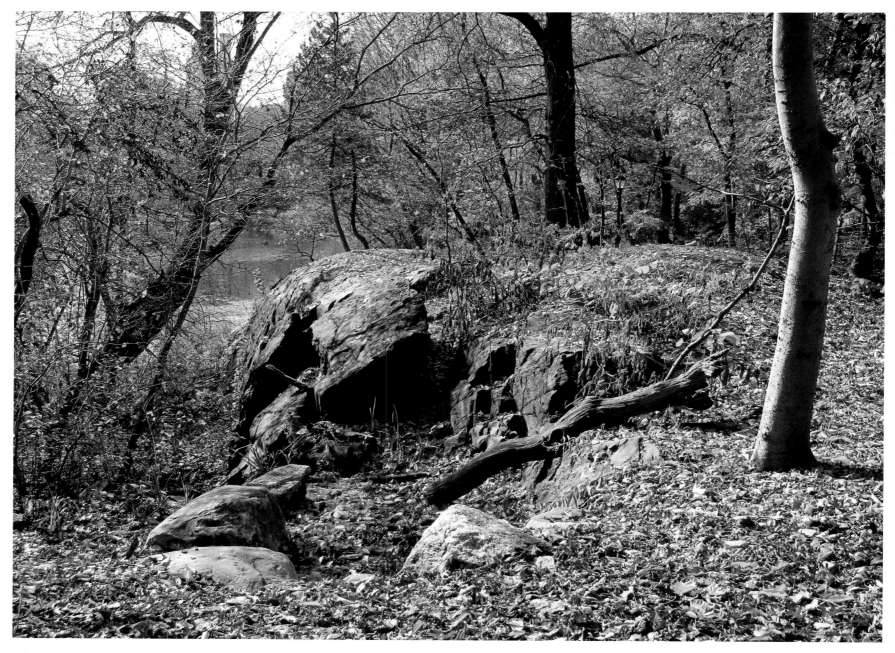

The Oven and Willow Rock, looking south toward the Lake.

THE BIRDS OF THE OVEN

This area bears two names but is basically the same location. The Oven is a small inlet on the north shore of the Lake, overgrown by willows and silted up. It is a reliable location to find warblers, and, during late winter, American Woodcock. Willow Rock is the rock ledge on the western edge of the Oven. The tall trees to the west of Willow Rock are good for canopy birds, and the willows themselves bring all sorts of warblers and other passerines down to drink. Other birds here include Nothern Waterthrush and Common Yellowthroat. Herons and Egrets are often found foraging along the shore. A Nelson's Sharp-tailed Sparrow is one of the more unusual birds to be found here (September 2002). The best place to overlook the Oven is from the west on Willow Rock itself, which also gives you a view down the western side of the Point.

—Phil Jeffrey
Phil Jeffrey is a structural biologist, Central Park birding expert, and photographer.

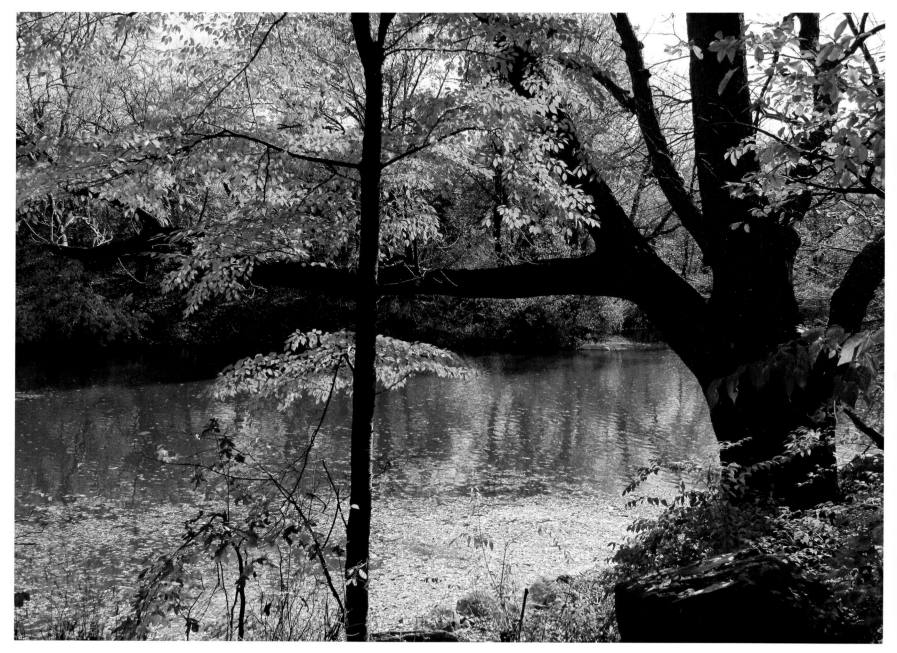

An old oak on the Riviera.

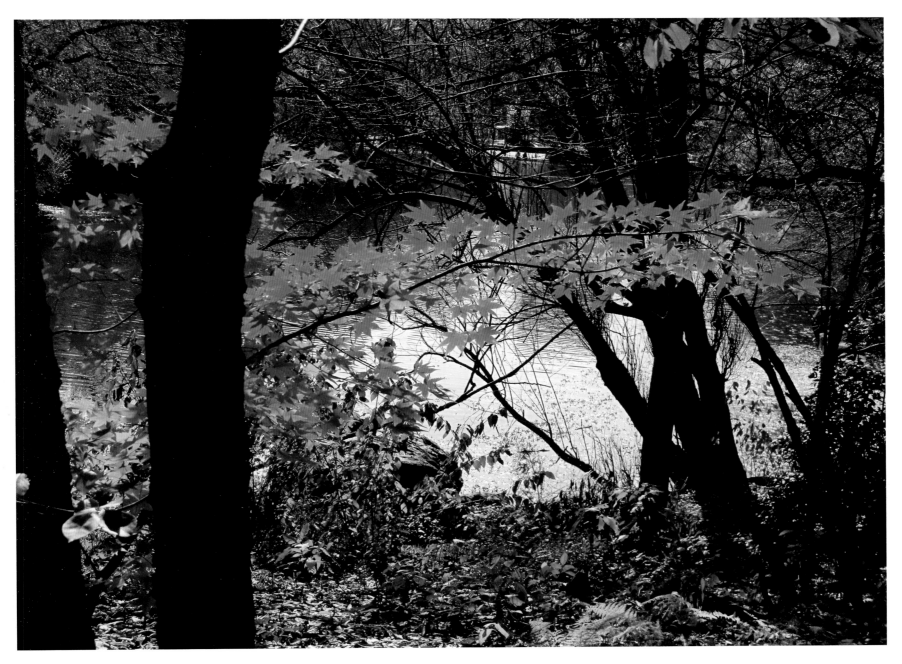

Japanese maple.

Crab apple.

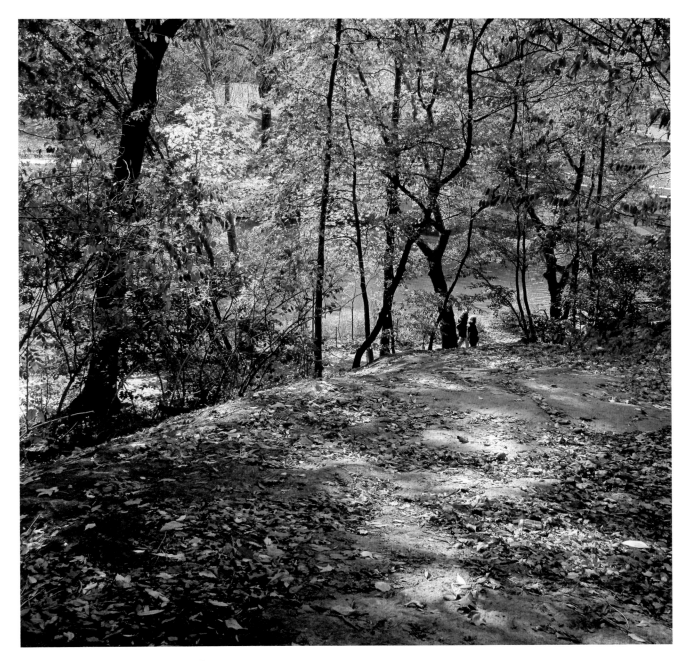

Warbler Rock, looking south over the Riviera.

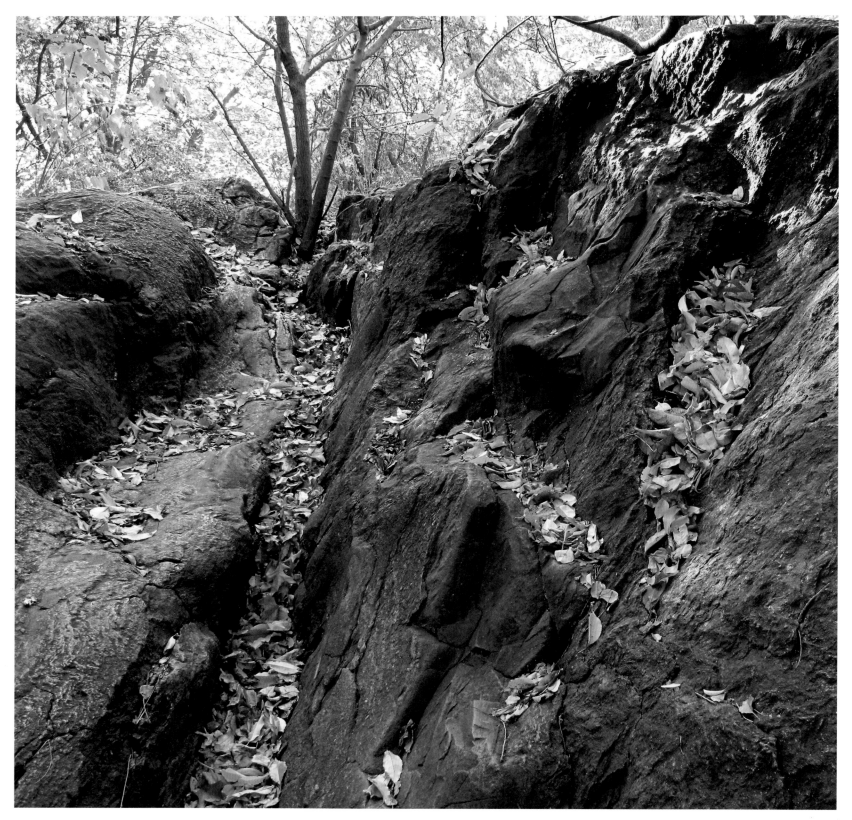

Leaf collection.

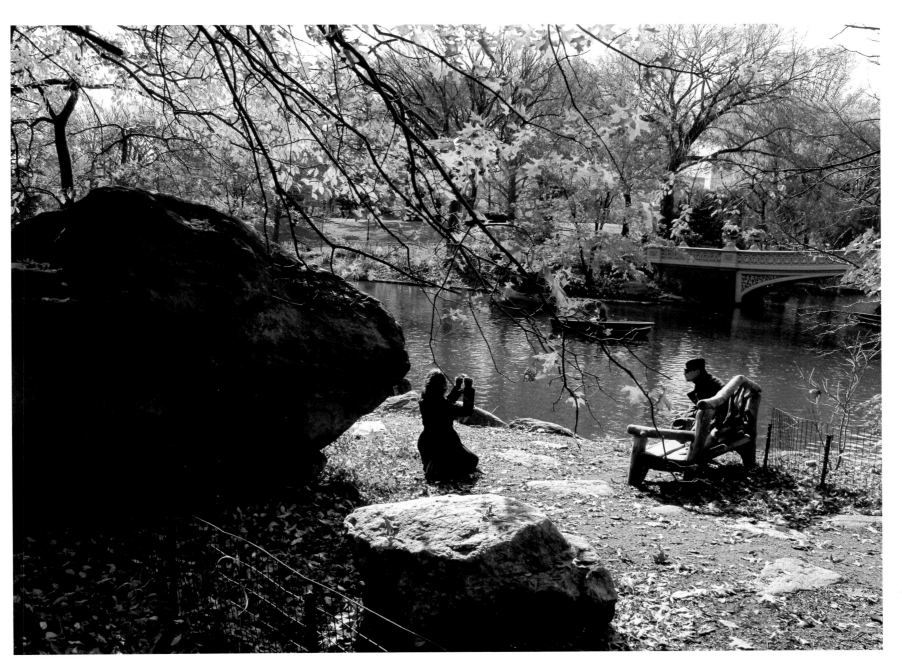

On the Riviera at the Bow Bridge.

The Riviera in fall. A sweet gum on the right.

The Riviera near Bow Bridge.

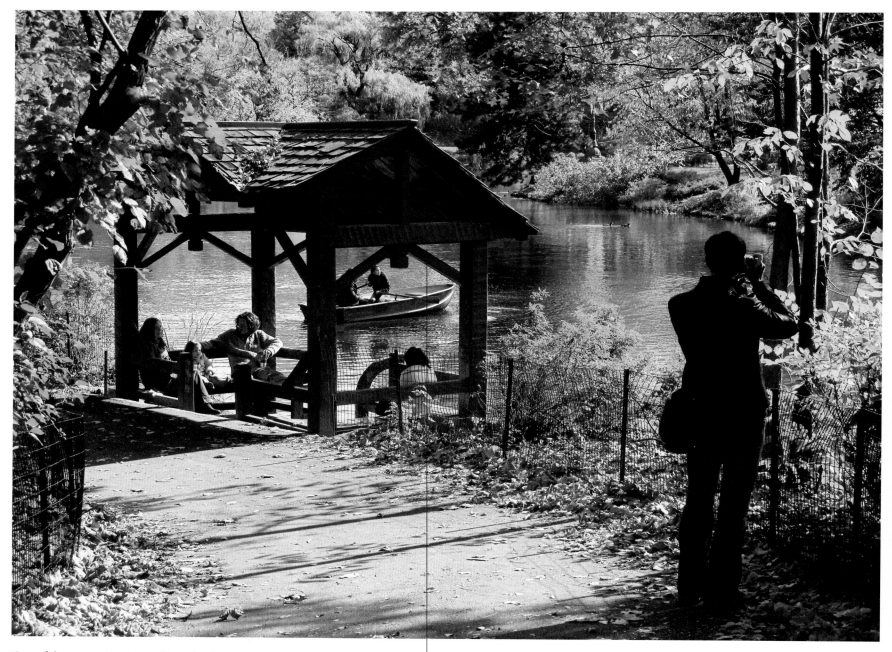

One of the remaining original boat landings, near the Bow Bridge.

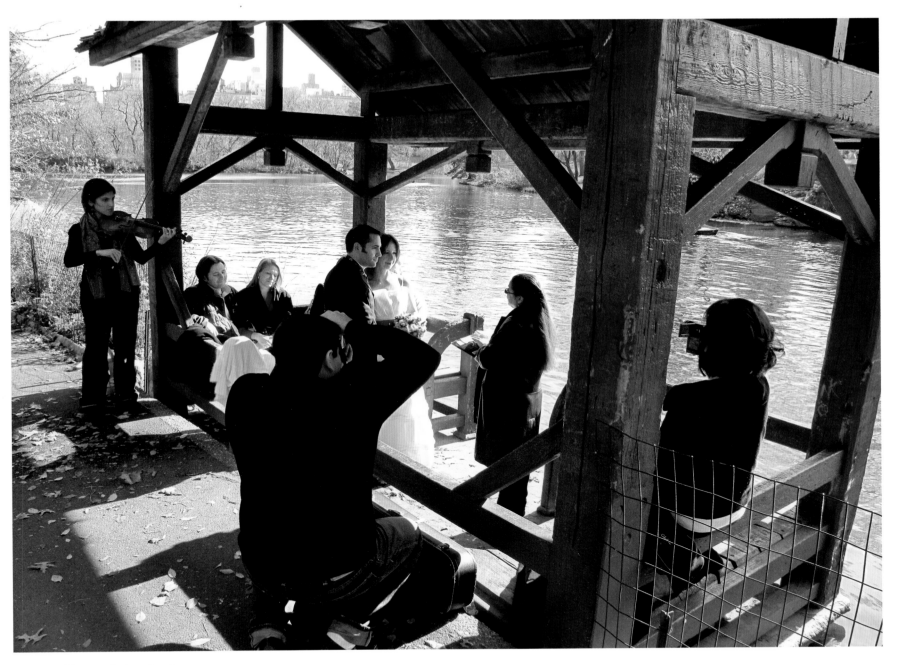

A fall wedding at the boat landing.

On Warbler Rock above the Riviera.

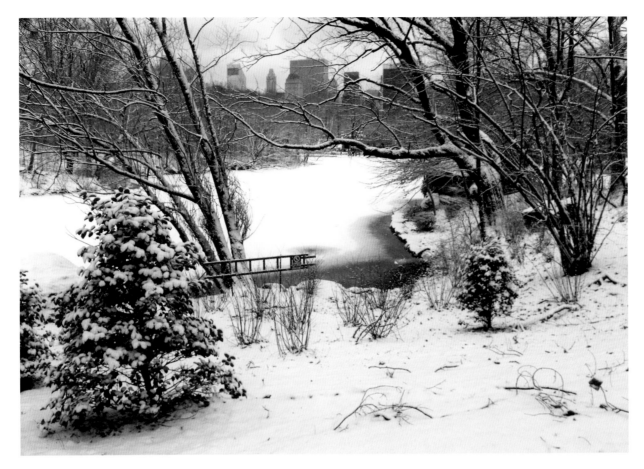

The Lake, looking west.

Central Park Lake follows the course of a small brook, the south branch of Saw Kill which derives its name from a sawmill built in 1664 by Jan Van Bommel at Avenue A. The stream gathered into a marshy pond in the hollow where the American Museum of Natural History now stands, then entered the park site between 76th and 77th Streets. It curved south around the Hernsbead, then ran more or less directly across the park through a wide marshy valley now occupied by the lake, the Terrace and part of the Mall, and then left the tract between 74th and 75th Streets on the Fifth Avenue side. As Olmsted wrote in his description of the prizewinning Greensward plan, "Mere rivulets are uninteresting, and we have preferred to collect the ornamental water in large sheets, and to carry off through underground drains the water that at present runs through the park in shallow brooks." In forming the outlines of the Lake, Olmsted took full advantage of the steep rocky bluffs on the north side, weaving around them little coves and bays that invite exploration, and creating the illusion of inlets to other lakes just around the bend. The superlative artistry of the design exemplifies Alexander Pope's mid-Eighteenth Century rules for landscaping: "Contrasts, the management of Surprises and the concealment of Bounds."

—From *Rock Trails in Central Park* by Thomas Hanley and M. M. Graff

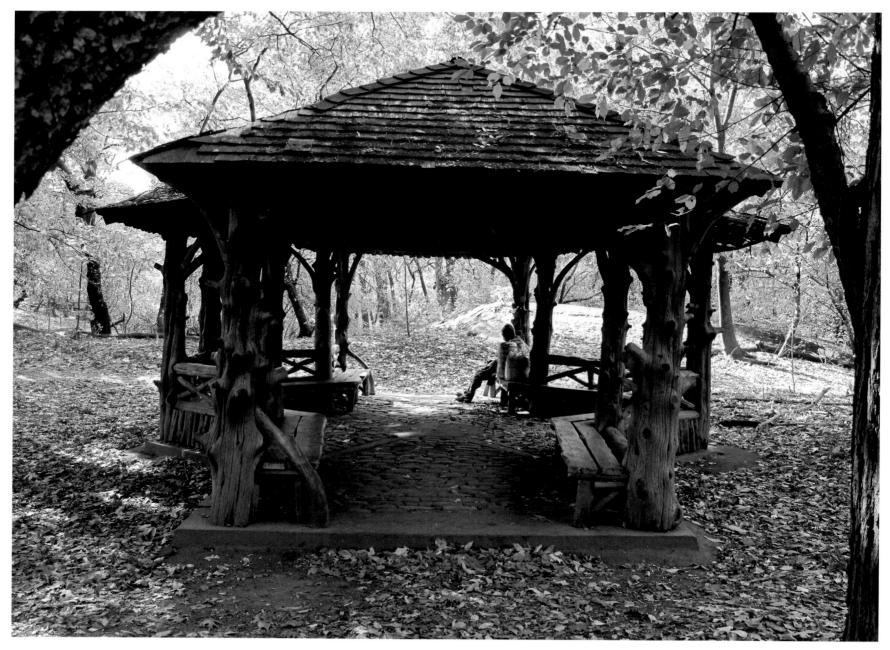

The Rustic Shelter.

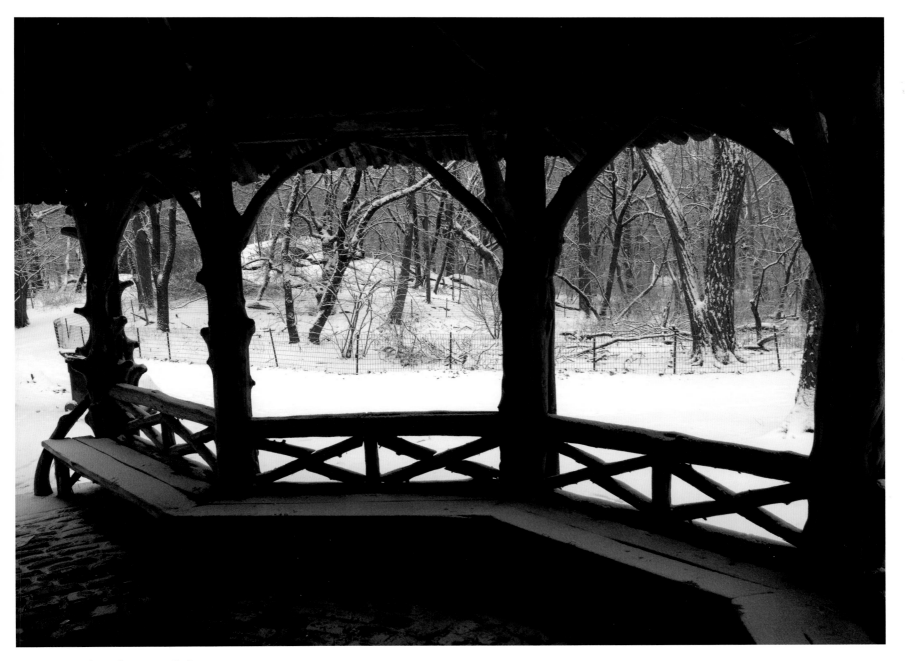

Winter view from the Rustic Shelter.

GILL CREEK VALLEY

The Source, the Headwaters, Azalea Pond,
Gill Rock, Laupot Bridge, the Gorge

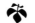

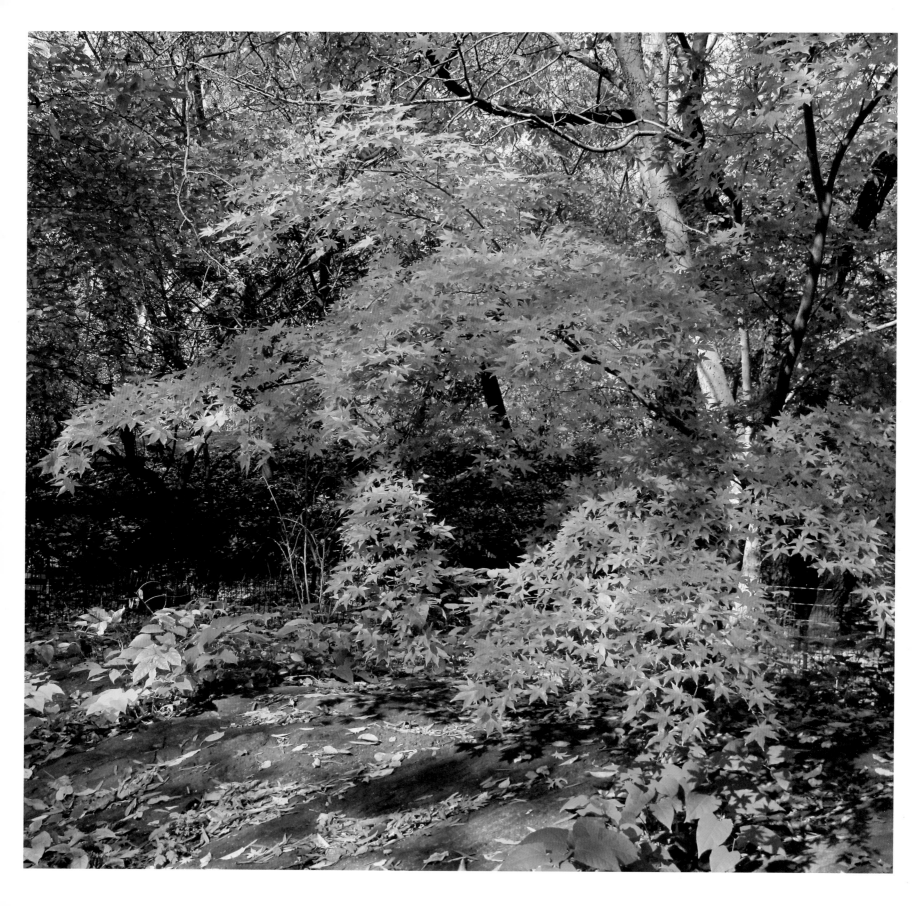

THE PLANTS OF THE RAMBLE

The Ramble is the soul of Central Park. It is certainly the best spot in the park to visit in order to escape the frantic pace of the city: it provides the experience of being in a secluded woodland while still offering tantalizing peeks of the surrounding city. *The New York Times* understood this early in the park's history: in a July 24, 1860 essay the newspaper opined that the Ramble "is the loveliest spot for afternoon walks and pleasant musings to be found within ten miles of New York."

Beyond what Central Park means to the people who visit it, the park, and its woodlands in particular, are an important part of the ecology of the northeastern United States. It sits directly on the Atlantic Flyway, one of the major migration routes birds take to and from their breeding sites. More than 270 species of bird live in or migrate through the park each year. And although birds are the most prominent wildlife in the park, there are also a variety of mammals, insects, fish, turtles, and frogs. In fact, there is much more wildlife in Central Park than most people might guess.

What supports all this wildlife in the middle of one of the busiest cites in the world? Plants. Most people do not give plants much thought beyond aesthetics or perhaps what services plants provide people. They appreciate how green the park is, the beauty and fragrance of the flowers, the shade a tree provides. However, plants are living beings. They form the basis of an intricate ecosystem, one that we have changed dramatically over the years.

Plants manufacture their own food from sunlight, carbon dioxide, and water. Almost all other organisms, including people, rely on these primary producers for their food. Even carnivorous animals rely on plants since they eat animals that eat plants. Plants provide the oxygen we need to breathe. They remove pollutants from the air, soil, and water. Plants are important factors in regulating weather cycles. In cities they help lower the surrounding temperature. Plants provide food, cover, and nesting material for wildlife, something that is scarce in urban environments. For people they provide a refuge from the hectic city environment.

As living organisms, plants respond to predators. The difference in how plants and animals respond to predation is that plants do not move around. They respond by producing chemicals that deter browsing and other forms of damage. We have learned to use some of these chemicals to our own benefit. More than 25 percent of commonly prescribed medicines are derived from plant sources—including aspirin (from the willow tree, *Salix*), the heart medicine digitalis (from the foxglove plant, *Digitalis*), the anti-cancer drug paclitaxel (from the Pacific yew tree, *Taxus*), and the anti-malaria drug quinine (from the rainforest tree, *Cinchona*).

The list of benefits goes on. As cities spread, green areas become more and more fragmented. Within these fragments native plants are lost, invasive plants take over, soil is compacted, and organisms die. It is up to us to care for the plants in our area. With so many visitors to Central Park (over thirty-five million per year!), plants need our care and protection.

Plant life in Central Park has undergone many changes over the years. The initial composition of exclusively native plants has been altered by the introduction of nonnative species. The original inhabitants of the area that is now Central Park planted species around their dwellings for food and medicine, species that often came from overseas. During the construction of the park and through subsequent upkeep and renovations, many horticultural species were introduced. Species were chosen without regard to their origin, but solely for their ability to survive, and their aesthetic value. We have since learned that many of these nonnative plants are detrimental to the local ecology—reducing or eliminating viable wildlife habitat. A few invasive species are so aggressive that they actually eliminate native plants, thus reducing overall biodiversity. A recent survey of the flora of the park has shown that 60 percent of today's plants that regenerate on their own (this excludes seasonal plantings and nonreproductive varieties) are nonnative plants.

The ongoing restoration of the woodlands and other natural areas of the park by the Conservancy aims to

control these invasive plants and to establish healthy populations of native plants. This will help ensure that the birds and other wildlife that live in or migrate through Central Park will have a healthy environment for years to come.

The wonderful photos in this book show the beauty of many of these plants, native and nonnative alike. Next time you visit the Ramble, take a close look at the plants. Think about the role they play in the ecology of New York and how you can help protect them.

—Regina V. Alvarez

A native New Yorker, Regina Alvarez is the director of horticulture and woodland management for the Central Park Conservancy. She oversees all restoration and planting projects in woodland and wetland areas of the park, as well as directing four horticulture crews throughout the park. She has two master's degrees in biology and is currently enrolled in a PhD program in plant sciences. Her research topic focuses on the ecology of the woodlands of Central Park.

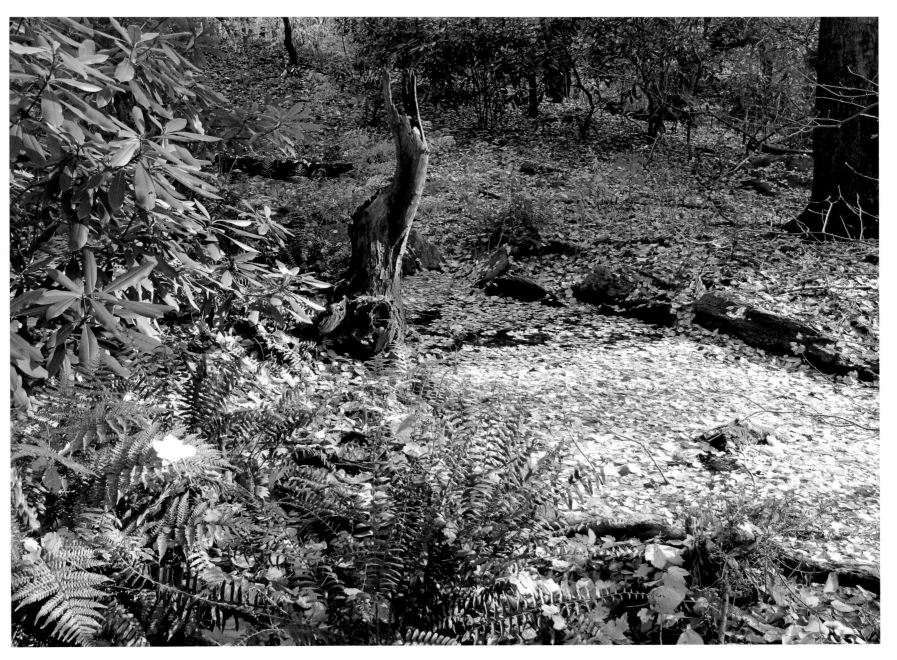

Was that a stag by the Gill this afternoon?

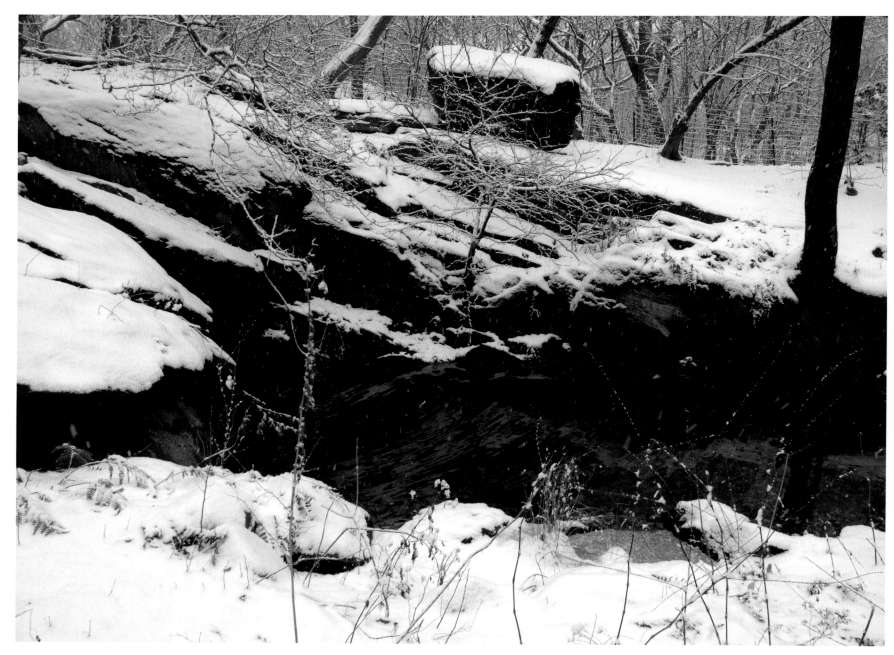

The source of the Gill in winter.

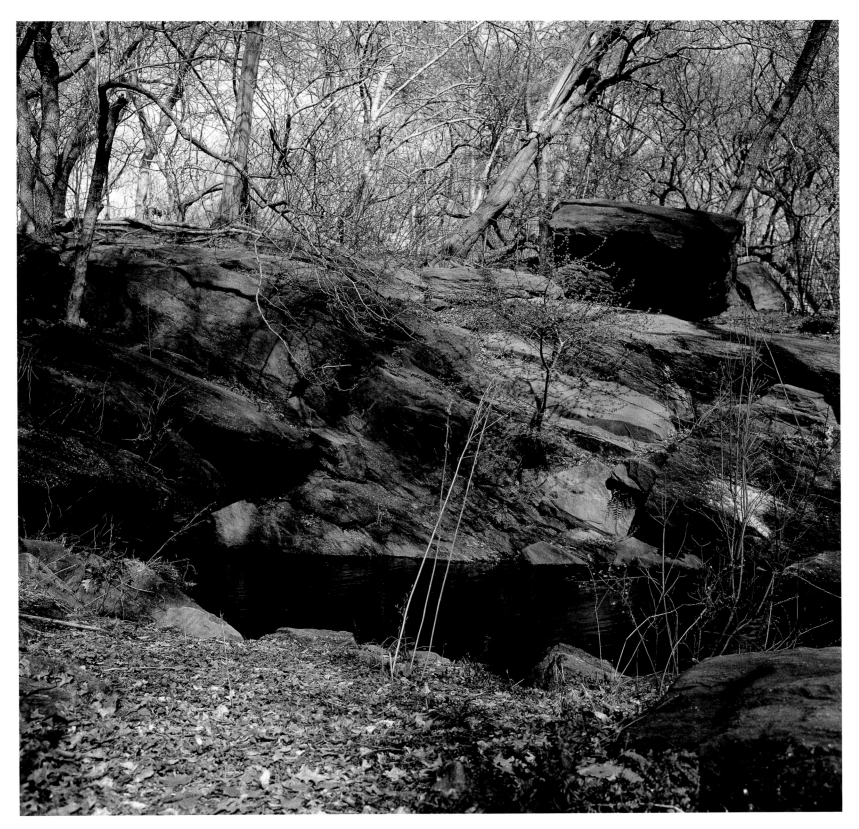

The source of the Gill in early spring.

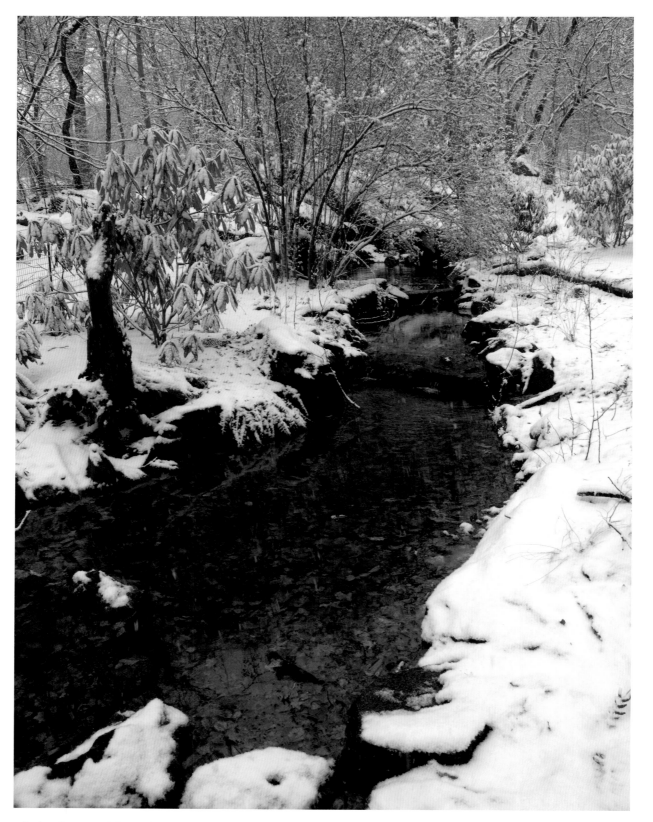

The headwaters of the Gill in winter.

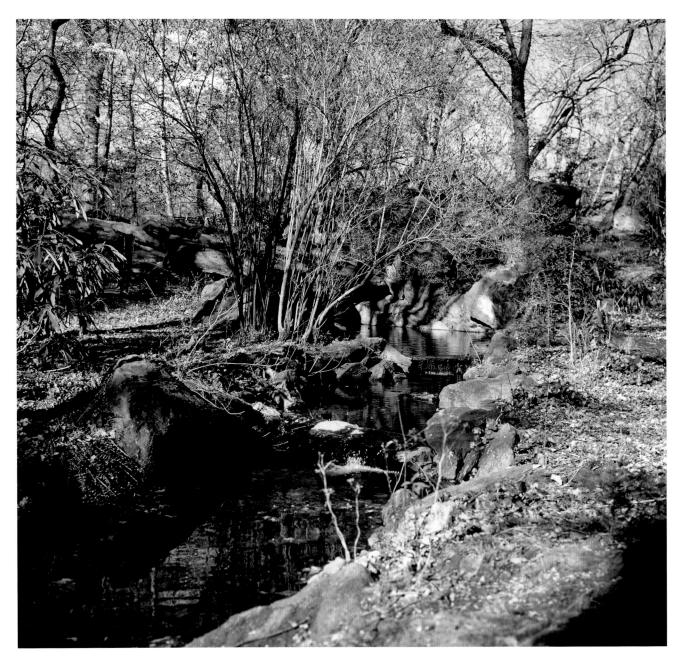

The headwaters of the Gill, with native marsh marigolds, in earliest spring.

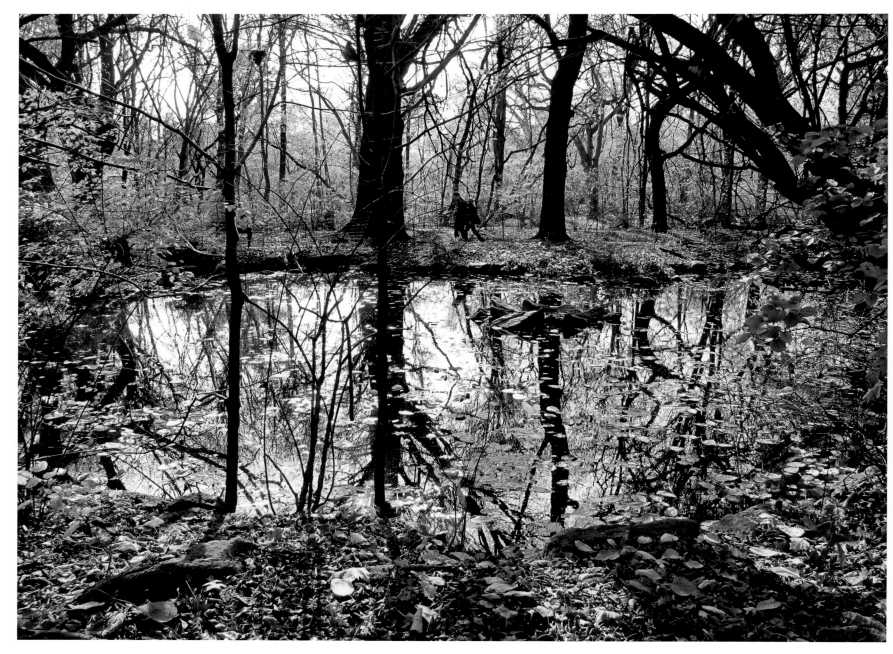

Azalea Pond.

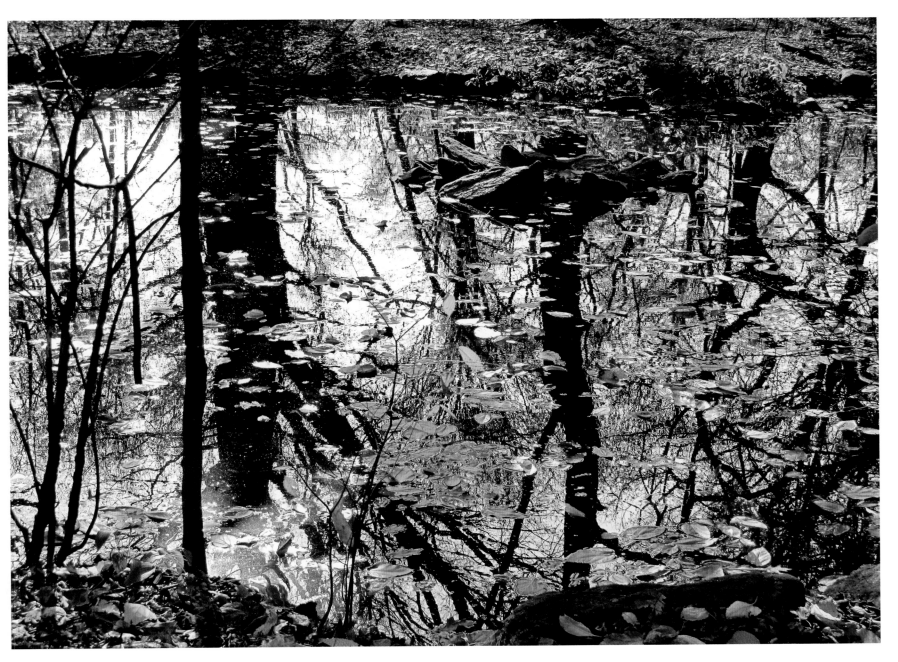

Reflections and leaves in Azalea Pond.

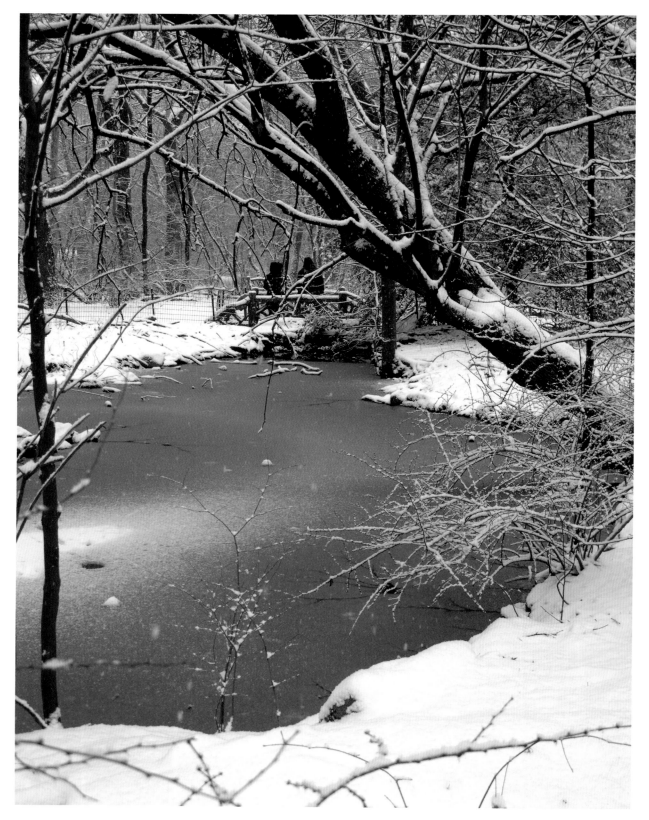

Azalea Pond and the Azalea Pond Bridge.

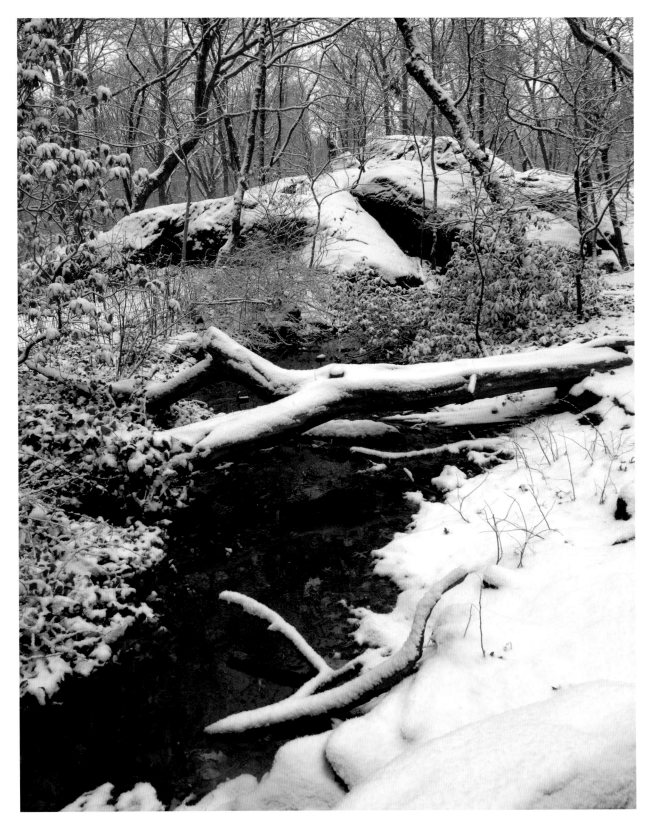

View from the Azalea Pond Bridge, looking downstream.

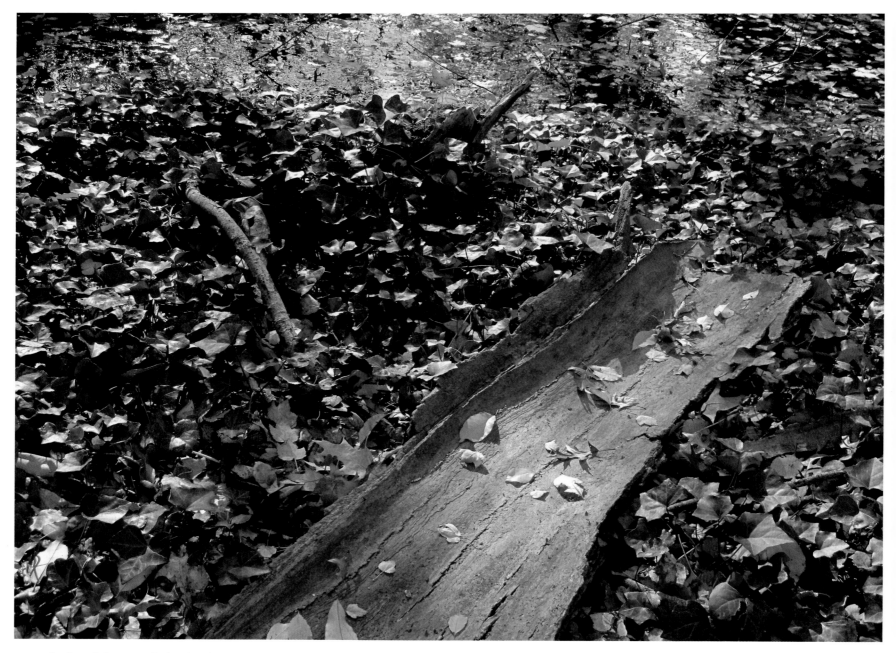

A patch of English ivy on the banks of the Gill.

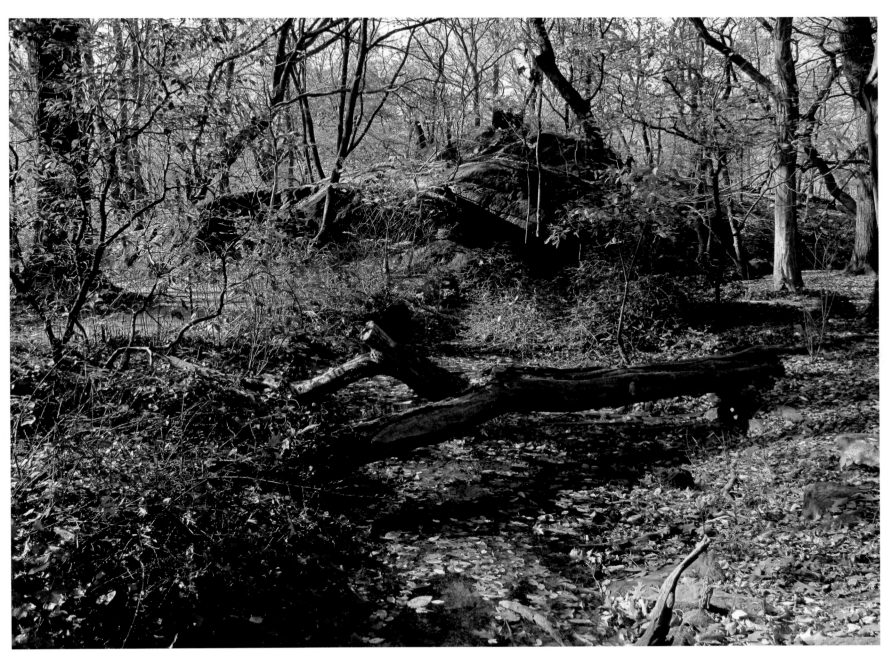

The Gill flowing through beds of English ivy and mountain laurel.

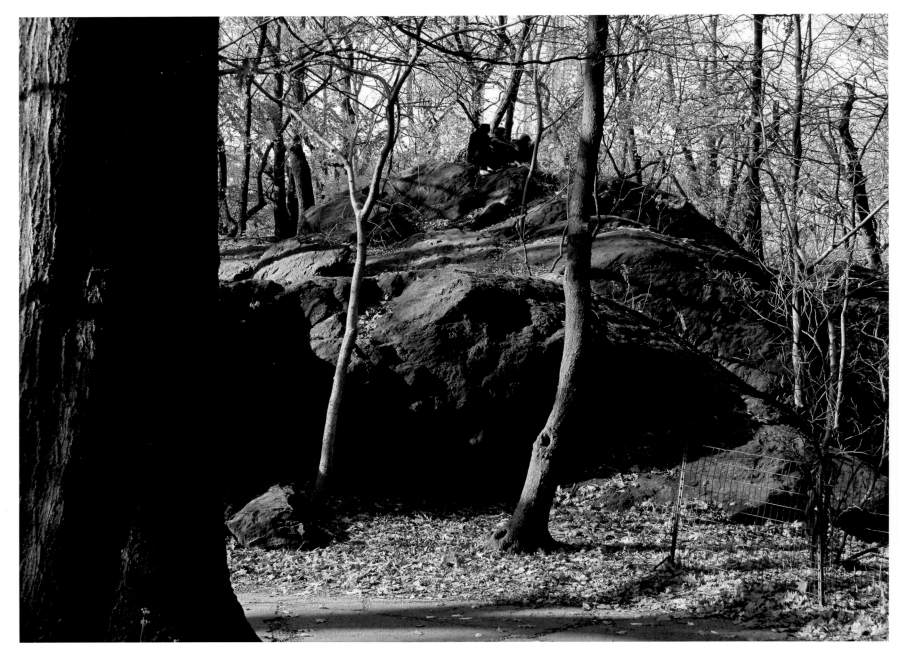

Gill Rock.

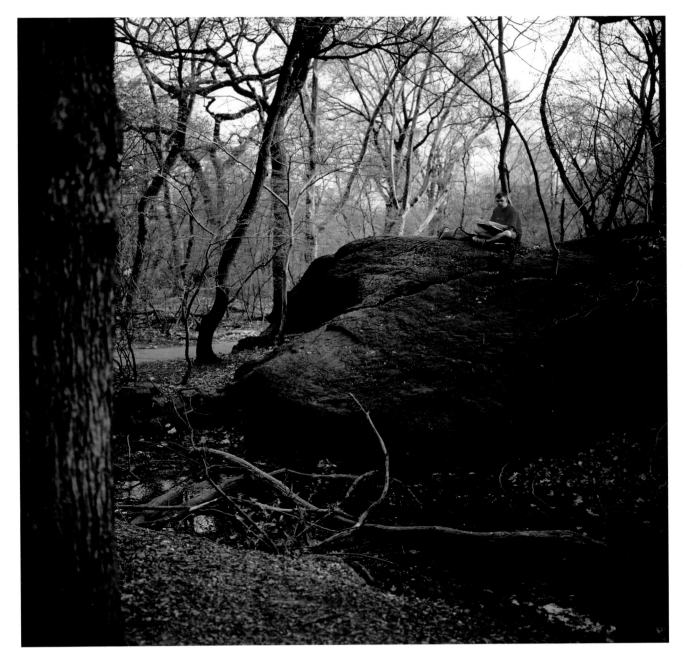

A rocky perch above the Gill.

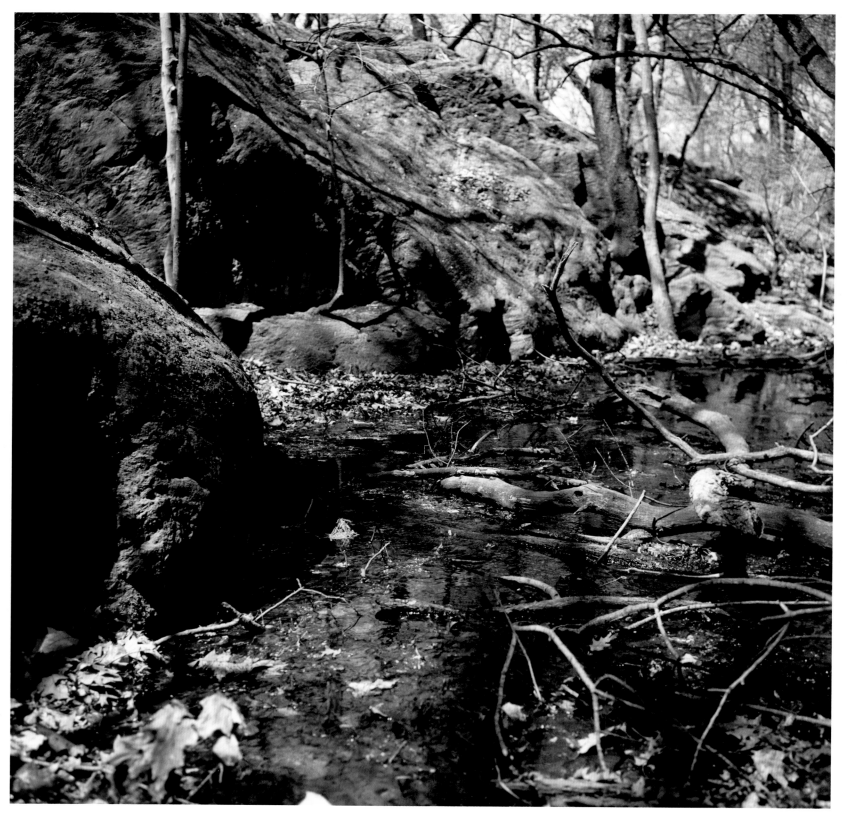

A pool in the Gill.

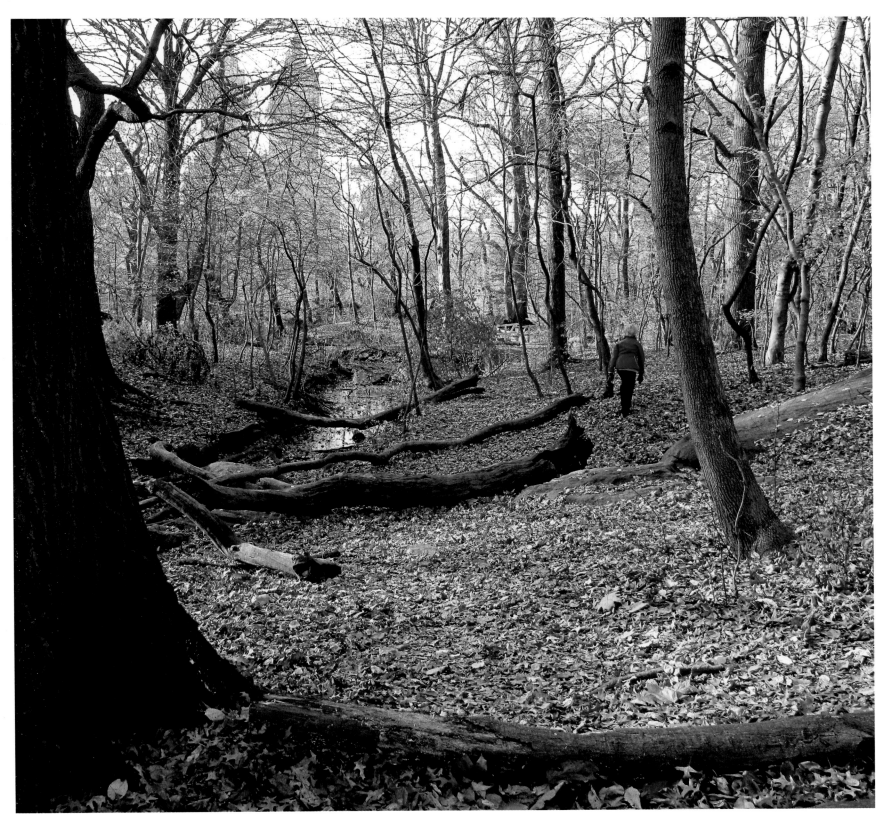

Near Azalea Pond.

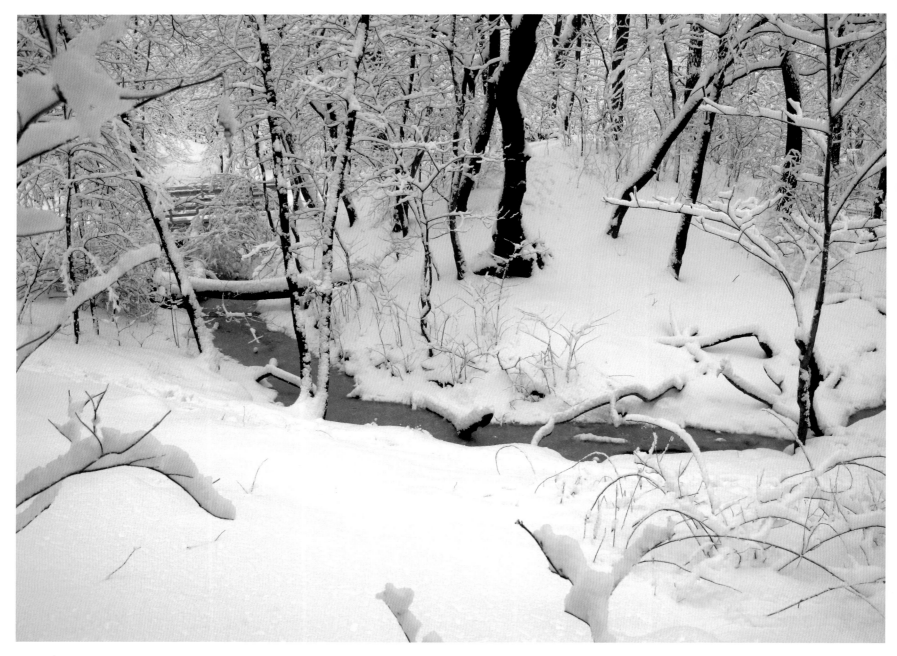

The Gill west of Azalea Pond in winter.

The Gill winds through the highlands west of Azalea Pond.

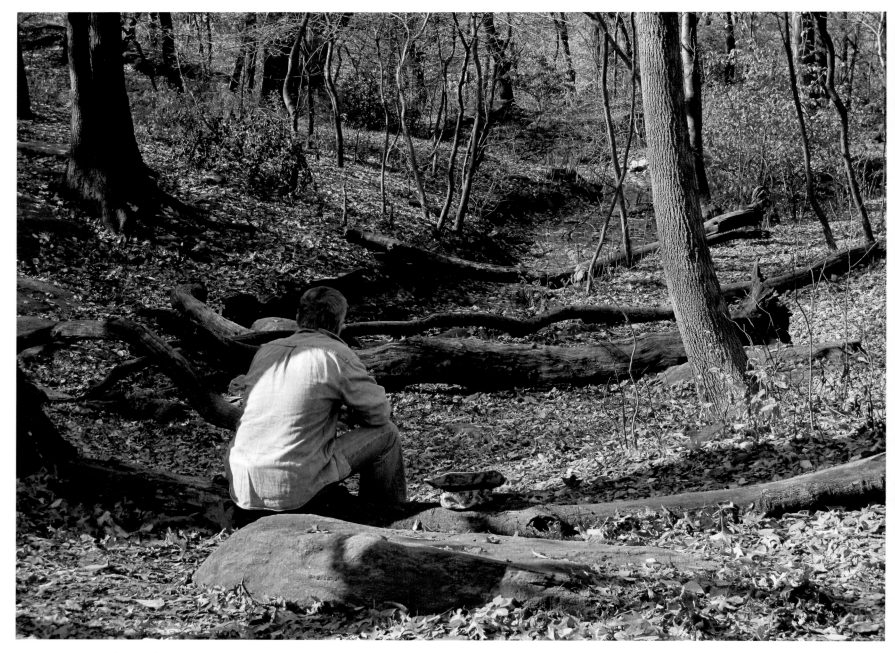

Autumn near Azalea Pond.

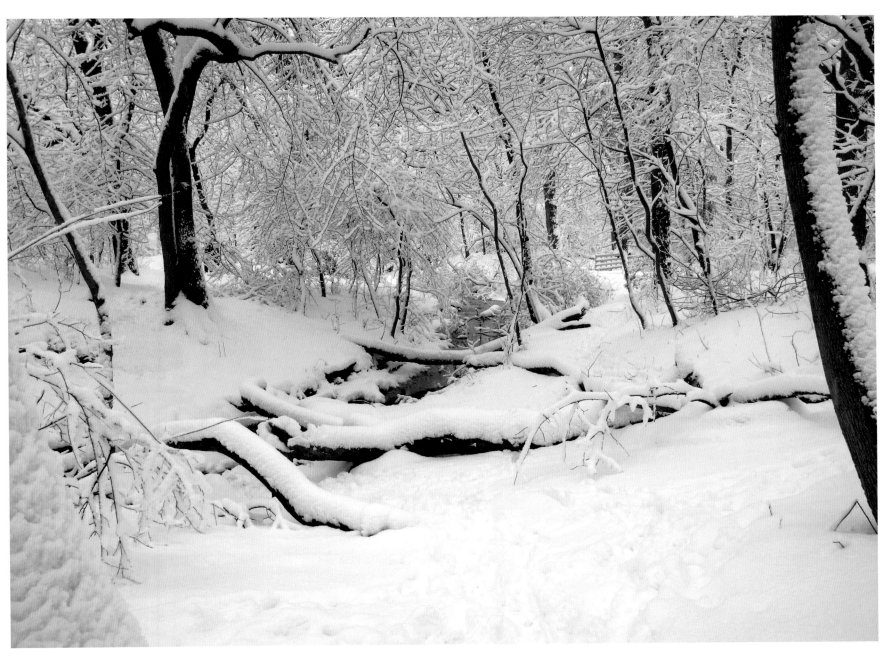

Winter near Azalea Pond.

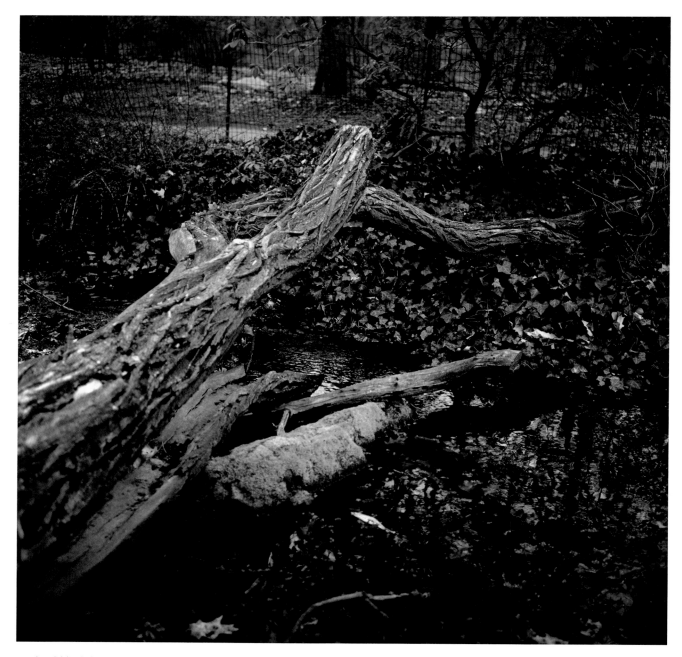

A dead black locust branch bridges the Gill in a patch of English ivy.

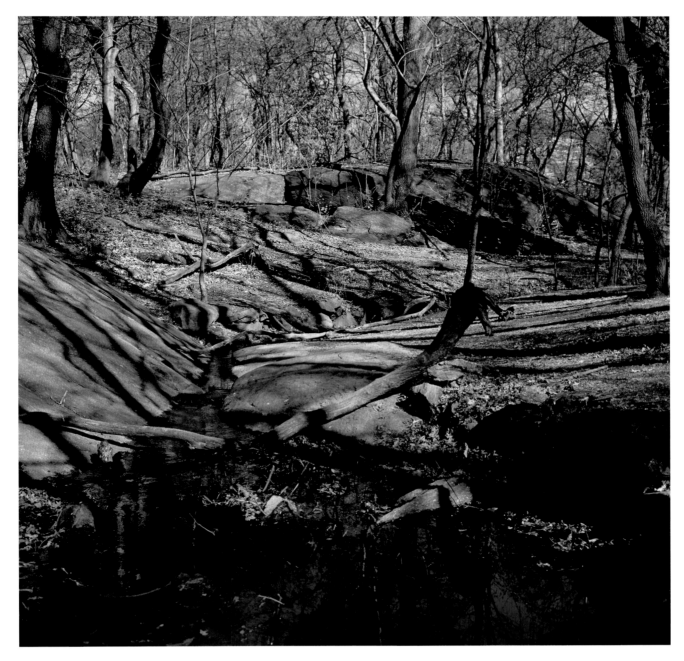

The Gill and its bedrock host.

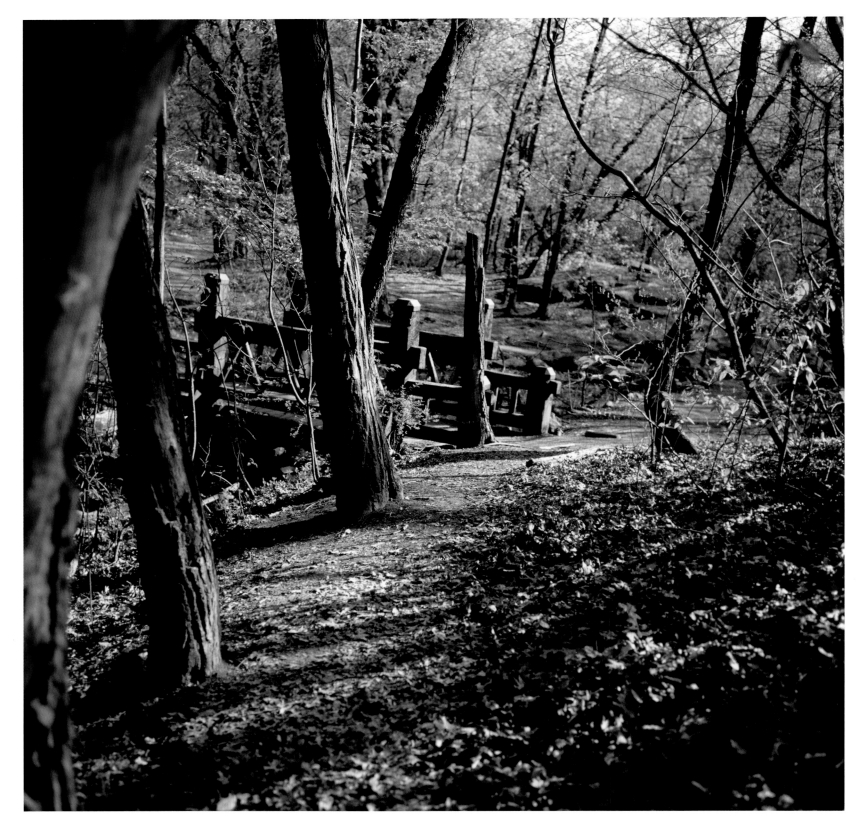

The Timothy Laupot Bridge across the Gill.

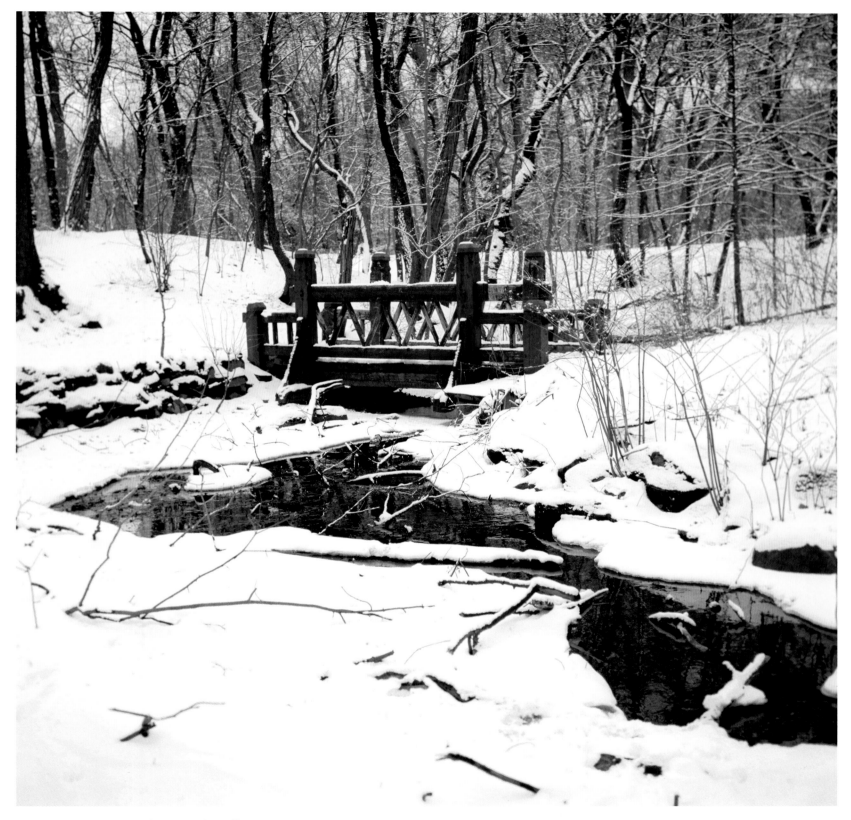

The Timothy Laupot Bridge across the Gill in winter.

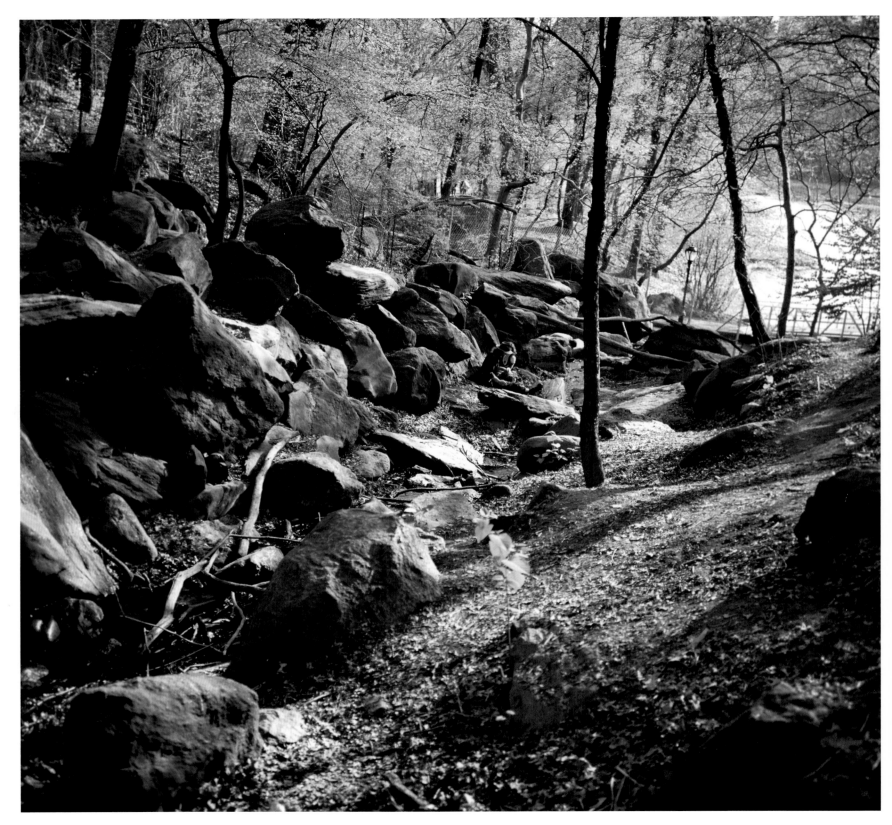

The Gorge.

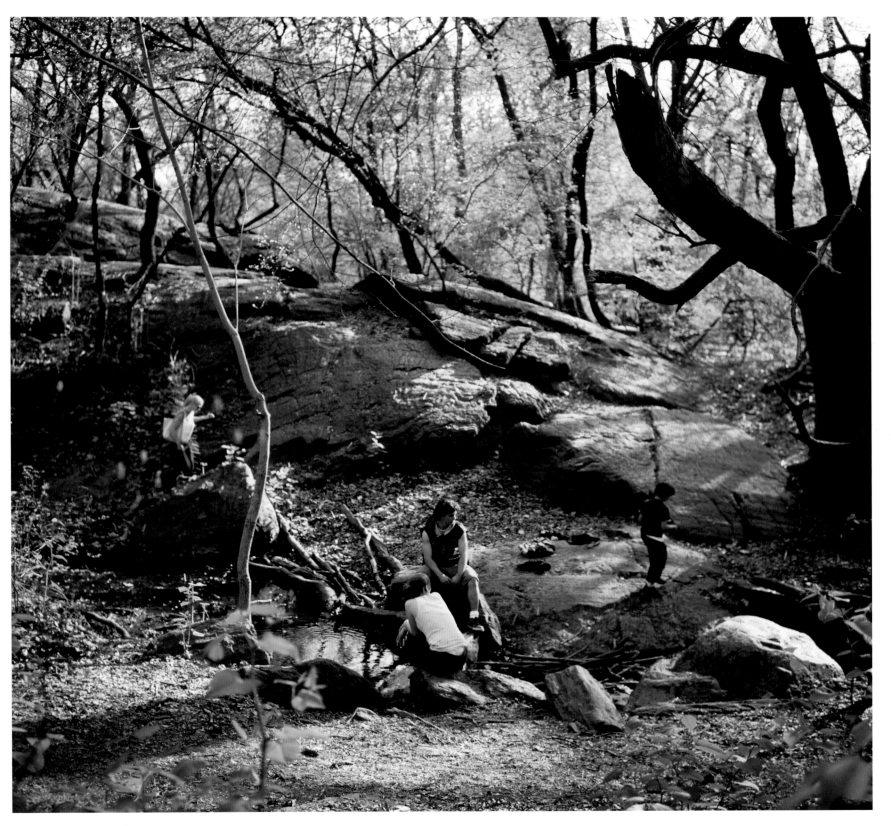

Springtime on the Gill.

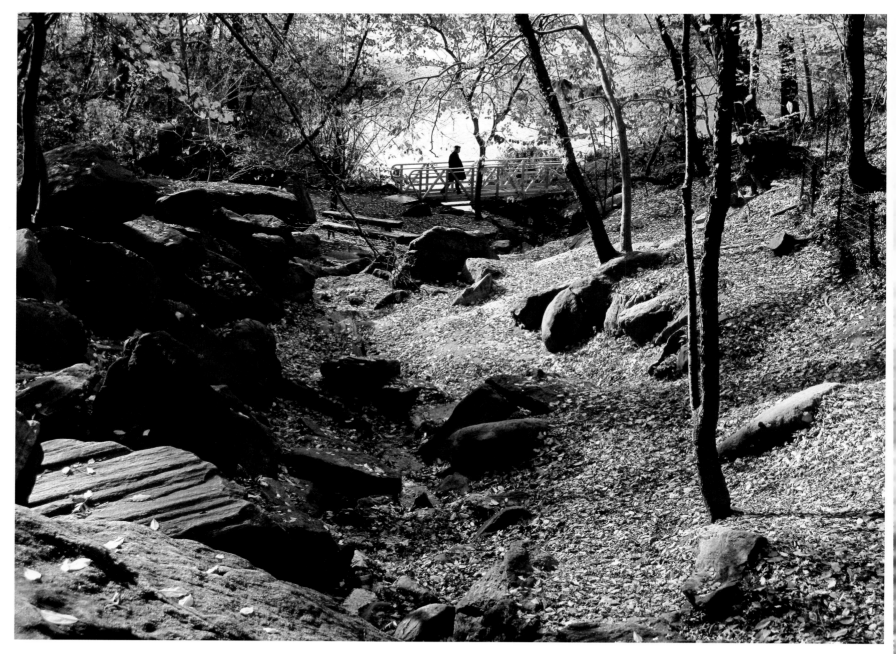

The Gorge in autumn.

Here the Gill empties into a stretch of rapids, a replica for city dwellers of a white-water stream in the Catskills or Poconos. Reversed from left to right, the scene bears an uncanny resemblance to Asher Durand's painting (to be seen in the New York Public Library's main building) in which William Cullen Bryant and Thomas Cole, founder of the Hudson River School of landscape painting, stand on a projecting rock shelf to admire a cataract and rushing stream in the ravine below. Olmsted based his reproduction of mountain scenery on the existing outcrop to the west, then added drama by building rocky banks and the rugged cliff from which the water issues.

—From *Rock Trails in Central Park* by Thomas Hanley and M. M. Graff

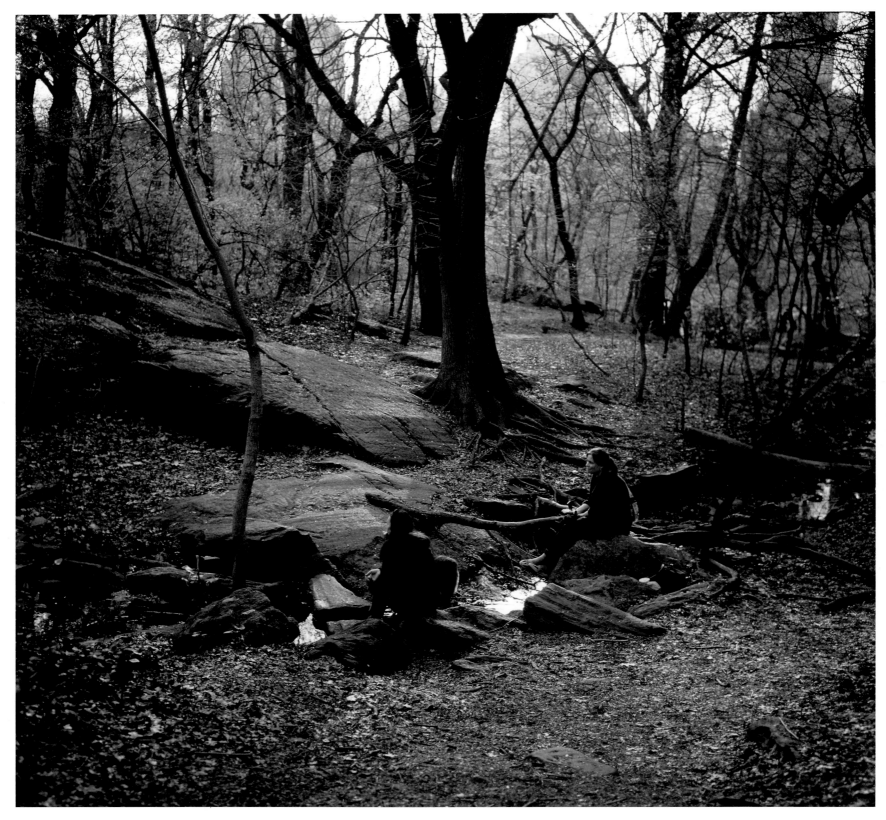

A tranquil spot on the banks of the Gill.

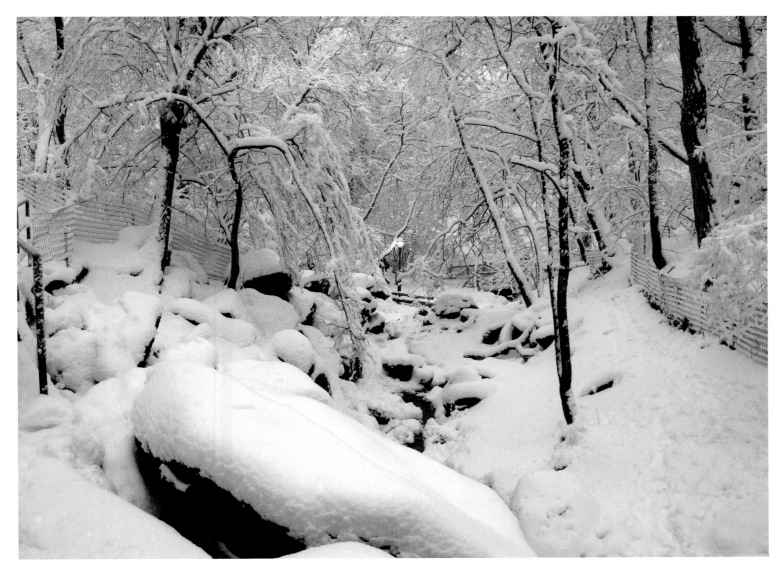

The Gorge in a blizzard.

THE GORGE

The storm was relentless. The visibility was so poor that none of the landmarks outside the Ramble that I normally use for orientation was visible. All the paths were covered. The coating on the trees and bushes was so heavy that you couldn't see beyond your immediate area. Although I know the Ramble extremely well I had a moment of, My God, where am I?

—Robert A. McCabe

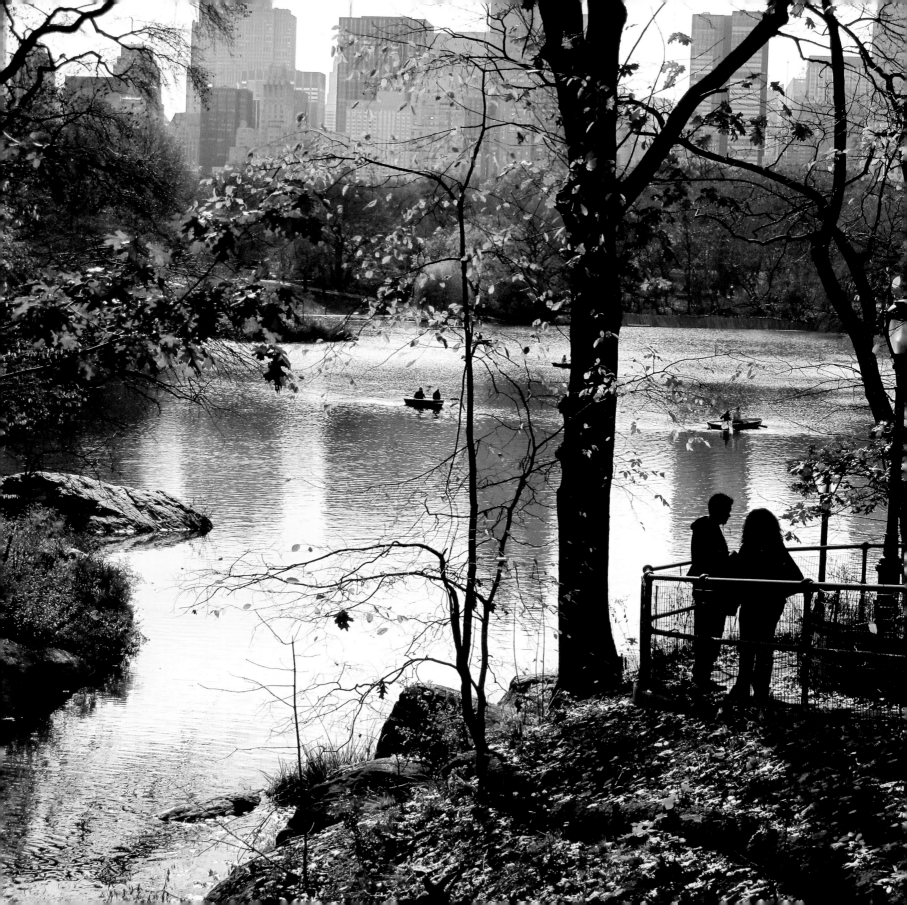

WEST

*Mugger's Woods, Indian Cave, the Inlet,
the Ramble Arch, Bank Rock Bridge*

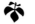

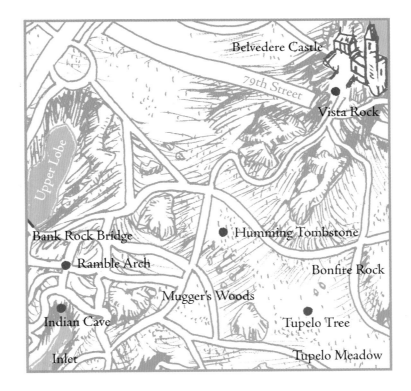

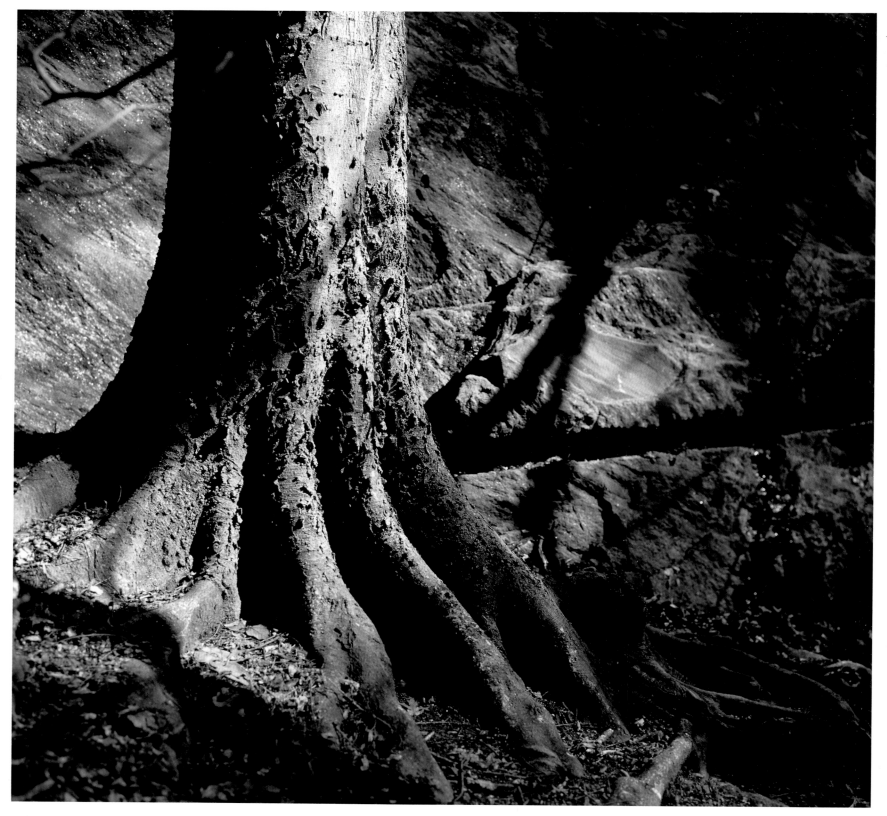

A hackberry and its bedrock companion in the late afternoon.

THE ROCKS OF THE RAMBLE

Stepping into the Ramble of Central Park over the Bank Rock Bridge is like crossing a moat that leads to a fabled landscape, a place that is in part rugged topography circumscribed by narrow, twisting paths. Whether it's for bird watching, navigating the winding walkways, or exploring the rocks and vistas, the experience of being in the Ramble is unlike that of anywhere else in Central Park. The geology of the place—complex, ancient, mysterious—creates a unique topography that is literally a blueprint of history, and affords the visitor an enormous step back in time.

In this special place, the natural features of the area's topography describe features of the underlying bedrock, contorted and fractured by earth forces over millennia. Although the exact age and origin of the bedrock are still open to discussion (some say that the bedrock is from the Manhattan formation, and therefore 560 million years old, while others claim that it is from the Hartland formation, 460 million years old), a clear picture has emerged that places the origin of these rocks at the bottom of a deep sea, adjacent to ancestral North America on one side and a volcanic island chain on the other. Sediments, the product of erosion from the two nearby land masses, accumulated to a formation thousands of feet thick. Inevitably, as is the way of our mobile earth, the two land masses began to converge, subjecting the sediments to enormous pressure and heat, and producing the rock type called schist, a metamorphic rock. As with all rocks, the layers formed are the pages of Earth's history; a simple walk through the Ramble is the experience of walking these pages.

Just after the entrance to the Ramble by way of Bank Rock Bridge is a path to the Ramble Arch, of particular geological interest. Even before stepping through the high rock walls of the arch itself, I should point out the dark gray and brown boulders from the 190-million-year-old Palisades, delivered to this spot some twenty thousand years ago by the great glacier that covered most of New York City. It is here that a visitor can appreciate the convergence of natural and man-made features of the Ramble: the rock outcrop on the right side is smooth bedrock, ground down by the grinding mill of the glaciers, and the left side is an embankment of giant rocks that the park's engineers put in place to support the arch. The arch itself is probably made of blocks of schist cut from long-forgotten outcrops removed during the development of the area. An intriguing mystery of the Ramble can be found on the arch: carved into three of the arch blocks are intricate designs of unknown origin.

And it is through the arch, too, that mysteries of history begin to reveal themselves. The exposed bedrock here shows in clear detail the contortions that the rock went through during its metamorphosis, a series of loops and bends and twists as convoluted as history itself. It is also possible to see the silvery mineral mica, more evidence of continental collision and the powerful forces of weather and erosion.

Further exploration into the Ramble reveals a fascinating relationship between glaciation and topography, affording a glimpse into the Ice Age. When glaciers reached New York City, they covered the area with a one thousand-foot thick mass of ice, relentlessly moving in a general southerly direction, scraping the bedrock like sandpaper because of the rock fragments embedded in the base of the moving ice. The smooth surfaces of the outcrops throughout the Ramble are testimony to this process, sloping in a characteristic whaleback shape. One such great slope is opposite the meadow from the location of the park's beloved sour gum tree. Other rounded hills have craggy edges created by the plucking action of the ice, the so-called *roches moutonnées*. As the glaciers began to melt away some eighteen thousand years ago, rounded boulders, dragged to the area by the glaciers, remained behind and today stand as a signature of the Ice Age. A careful look at these loose boulders, most of them dark gray or brown with no layering or banding, proves that they are not derived from the bedrock but were indeed carried from the Palisades. Many of these rocks are enormous; one cannot help but marvel at the power of the glacier to transport them. Others still were clearly situated by the park's designers, a fact that is as equally awe inspiring when a visitor thinks of the extreme skill and engineering know-how it must have taken to do so.

In the West: a rocky slope with the Dakota in the background.

The Ramble, a place of beauty, is one of the great treasures of New York City. It is here that the visitor can experience a peaceful, carefully designed setting and also witness evidence of the vast and powerful forces of both history and geology.

—Sidney Horenstein
Geologist and Environmental Educator Emeritus, American Museum of Natural History;
natural history consultant to the Bronx County Historical Society; and columnist for the journal
Evolution: Outreach and Education.

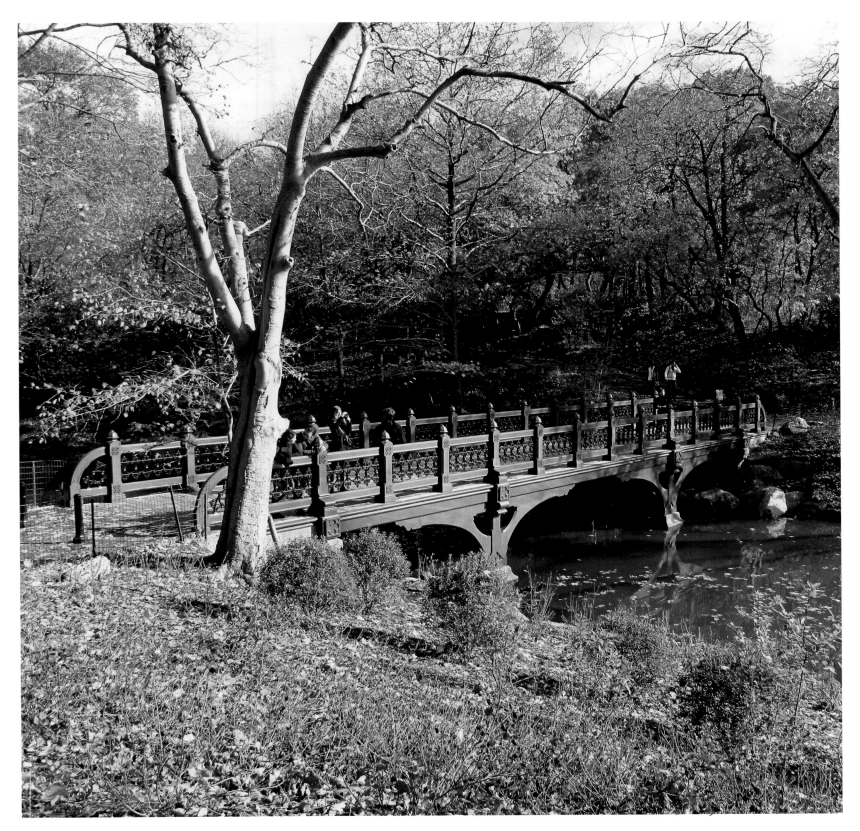

Bank Rock Bridge.

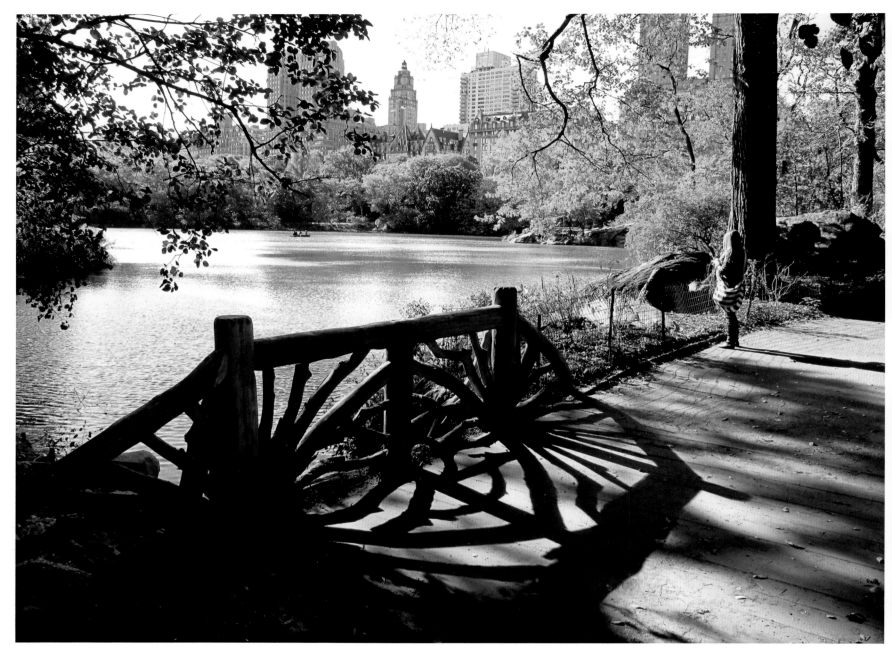

The new bridge at the mouth of the Gill, below the Gorge.

Bonfire Rock.

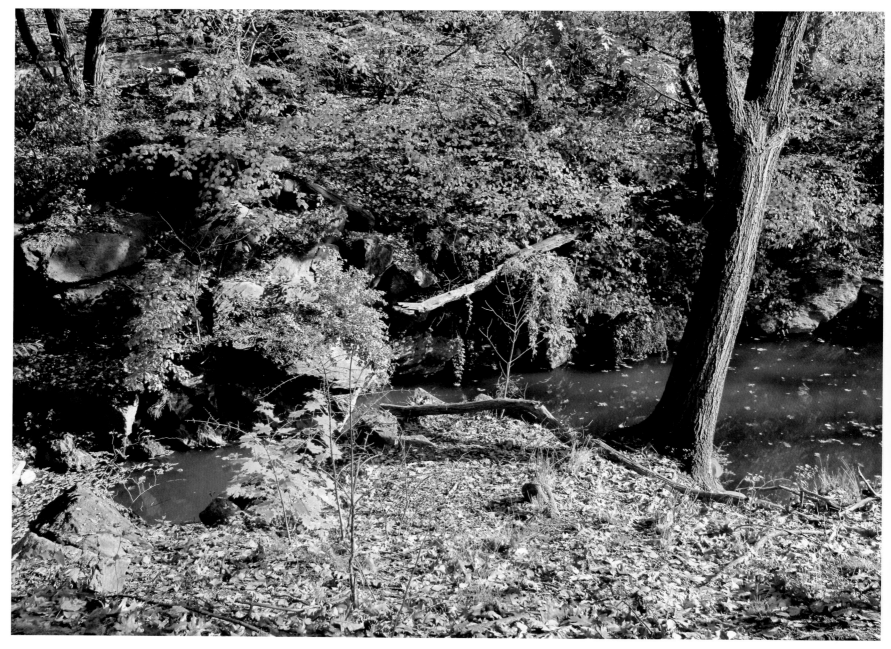

The Inlet from the West.

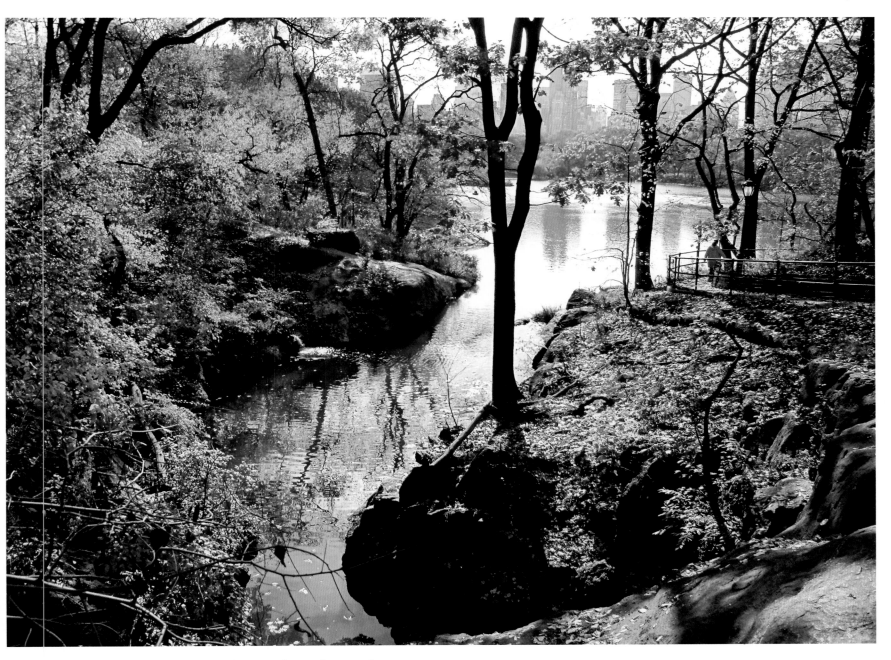

The Inlet, near the Cave, looking to the southwest, with an oak tree in the center.

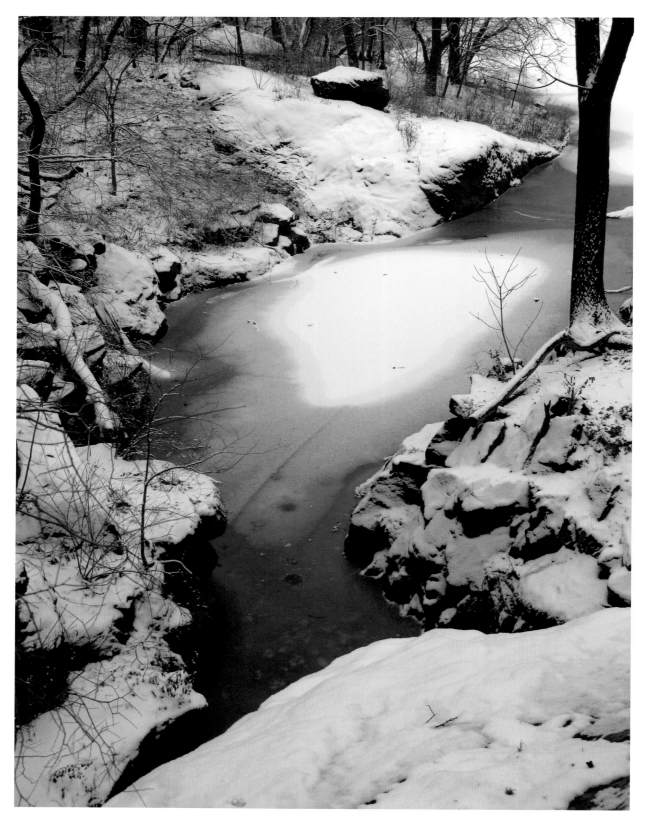

The Inlet in winter.

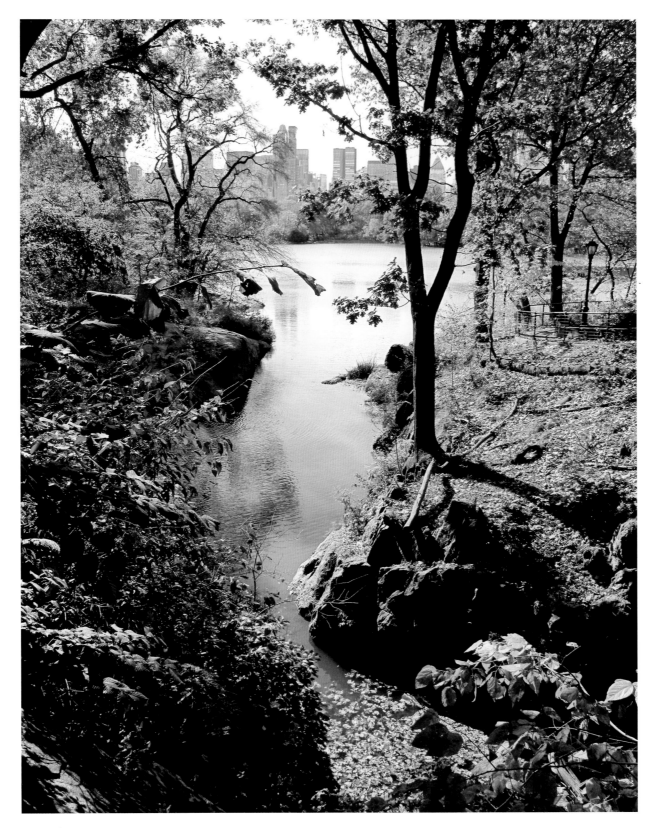

The Inlet.

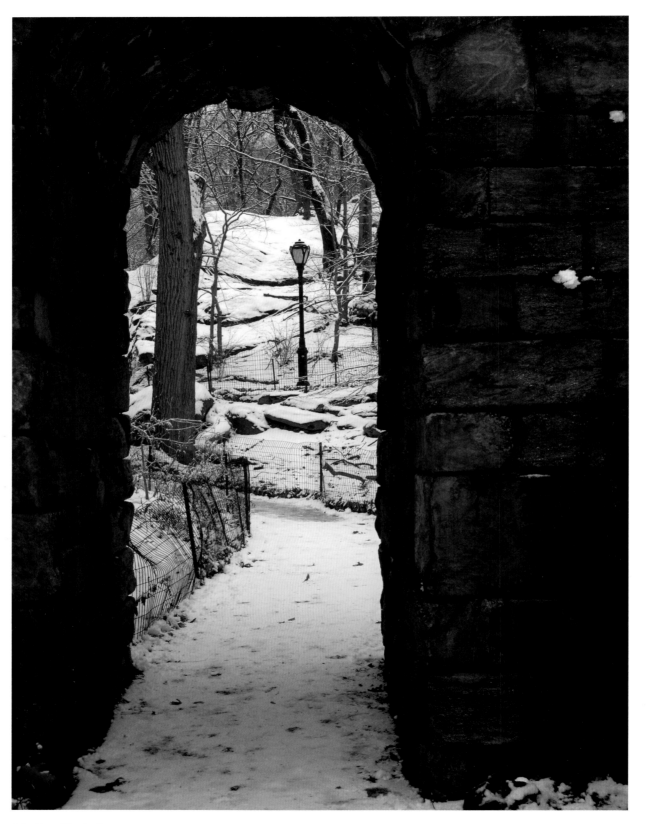

The Ramble Arch.

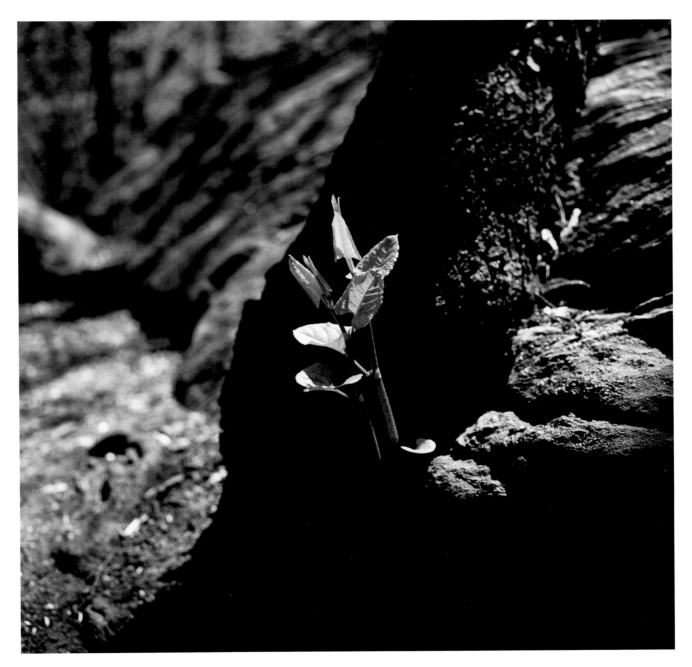

Japanese knotweed sprout near the trunk of a black cherry tree.

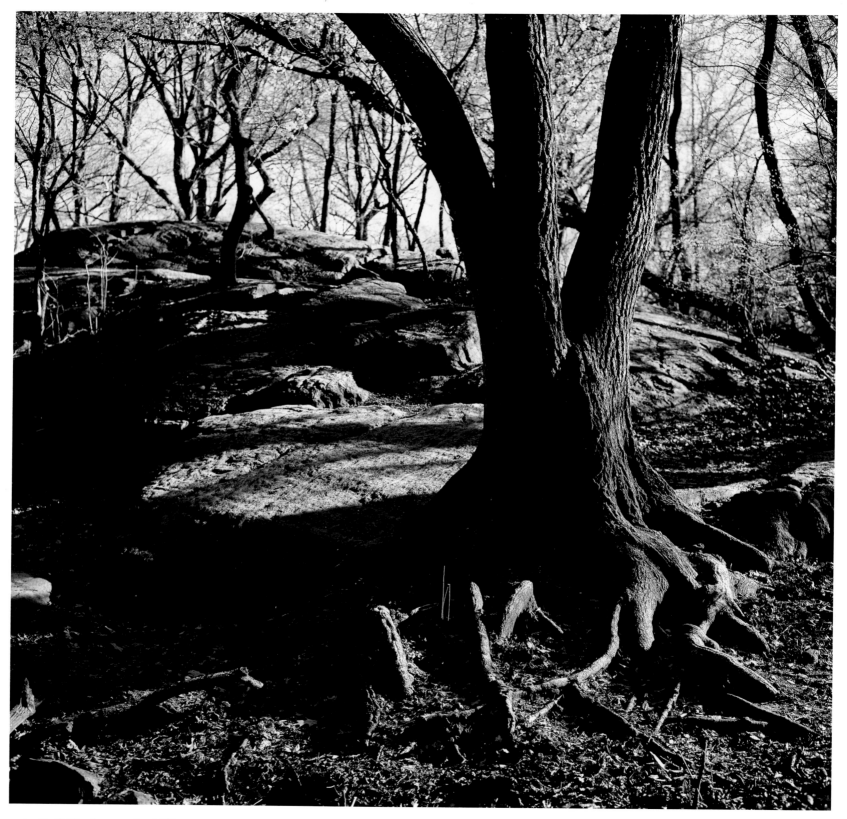

40° 46' 38" North, 73° 58' 14" West.

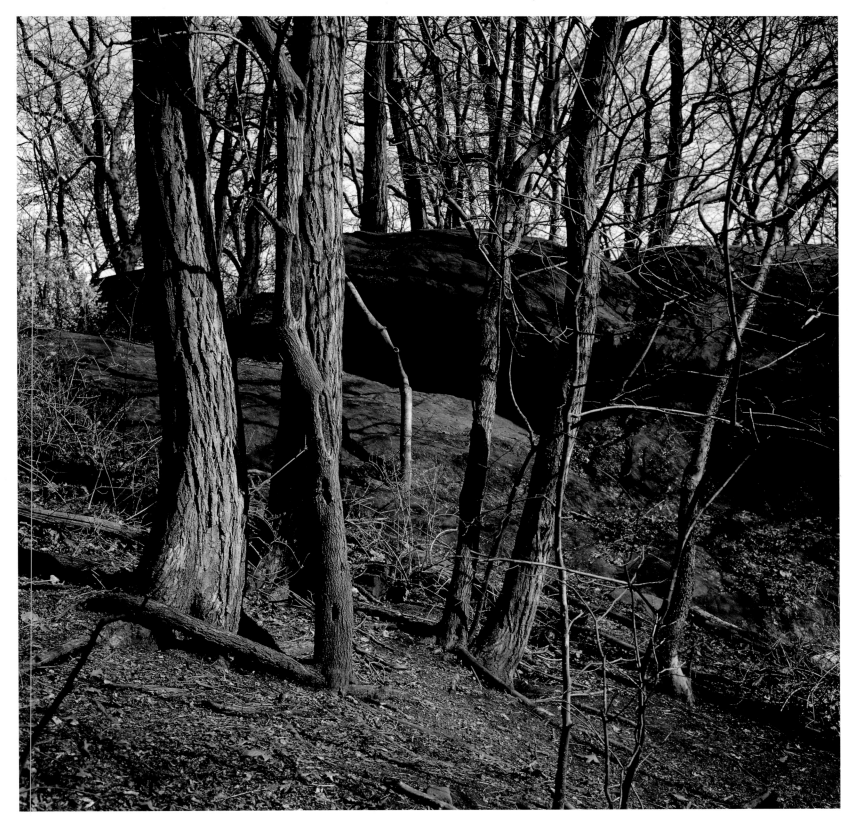

A grove of black locust and hackberry trees.

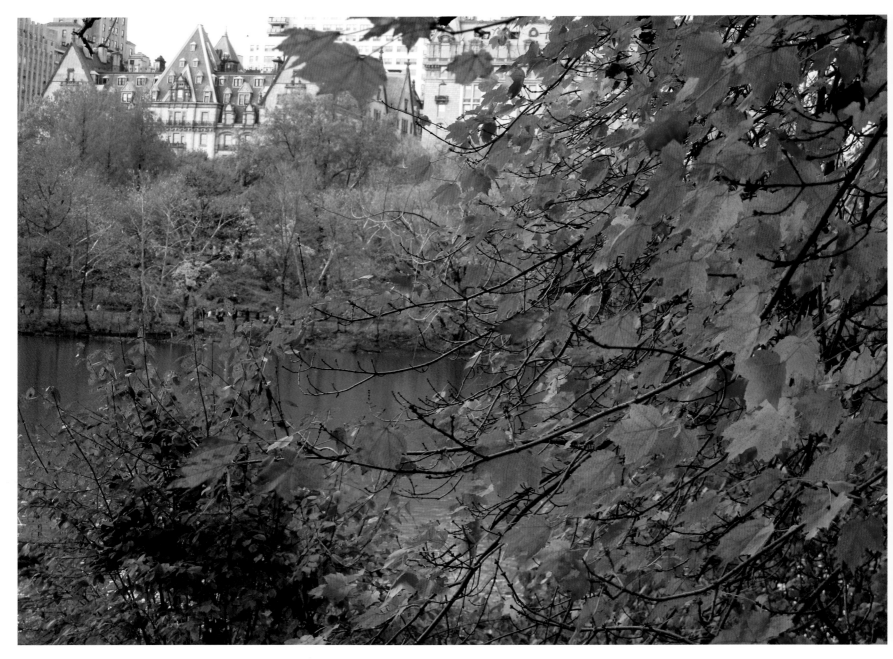

Red maple and the Dakota.

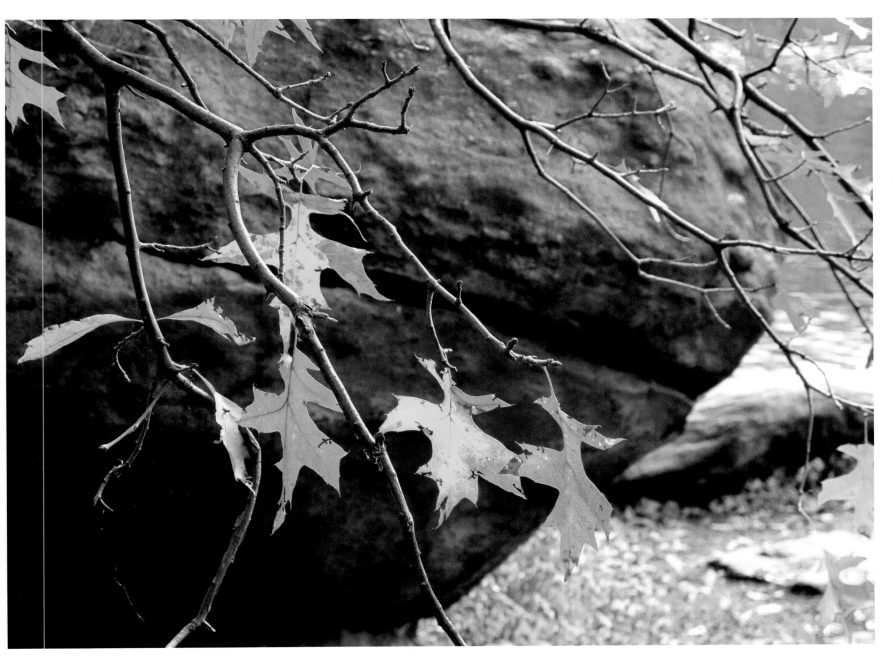

Pin oak.

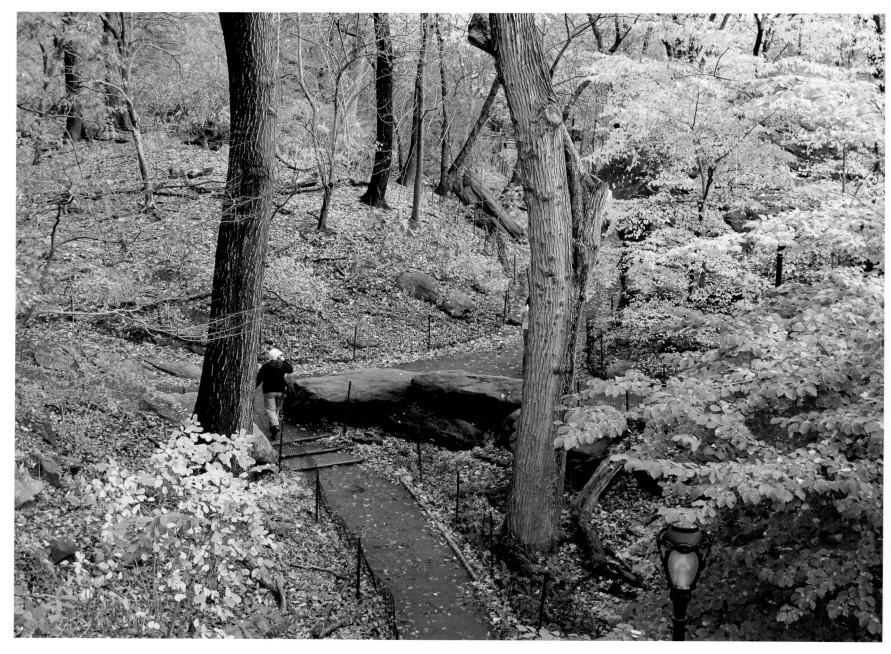

From the Ramble Arch, looking east.

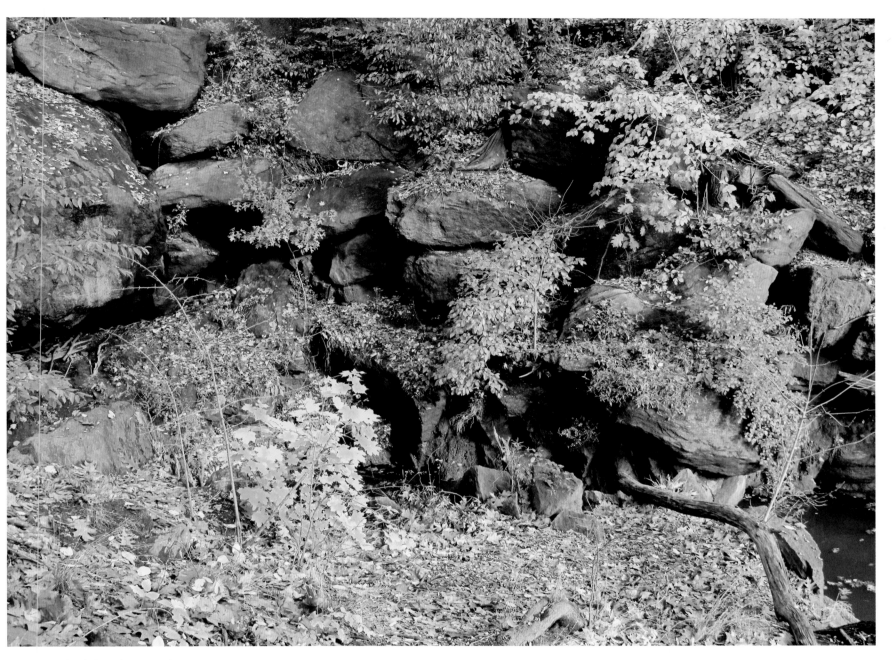

The east side of the Inlet, near the Cave.

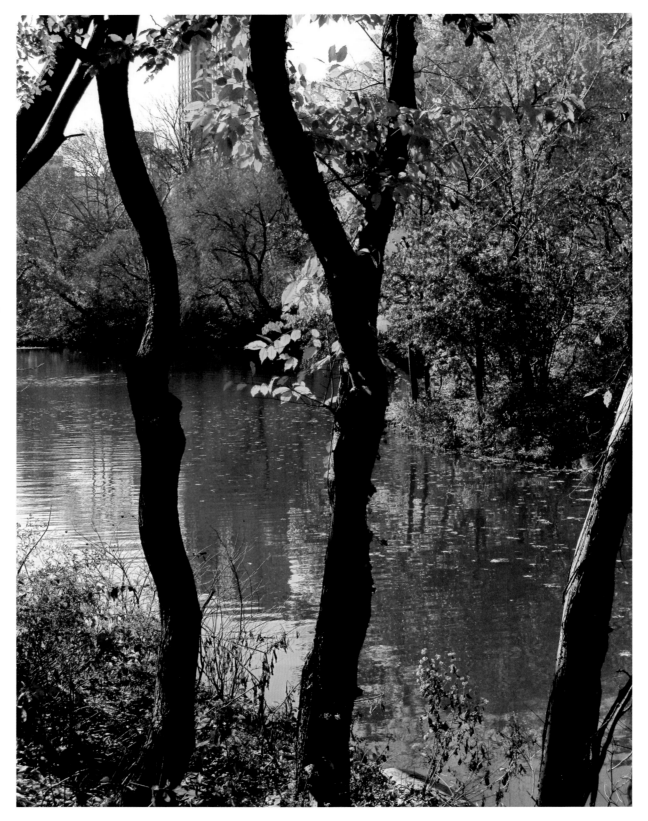

Black cherry trees south of Bank Rock Bay.

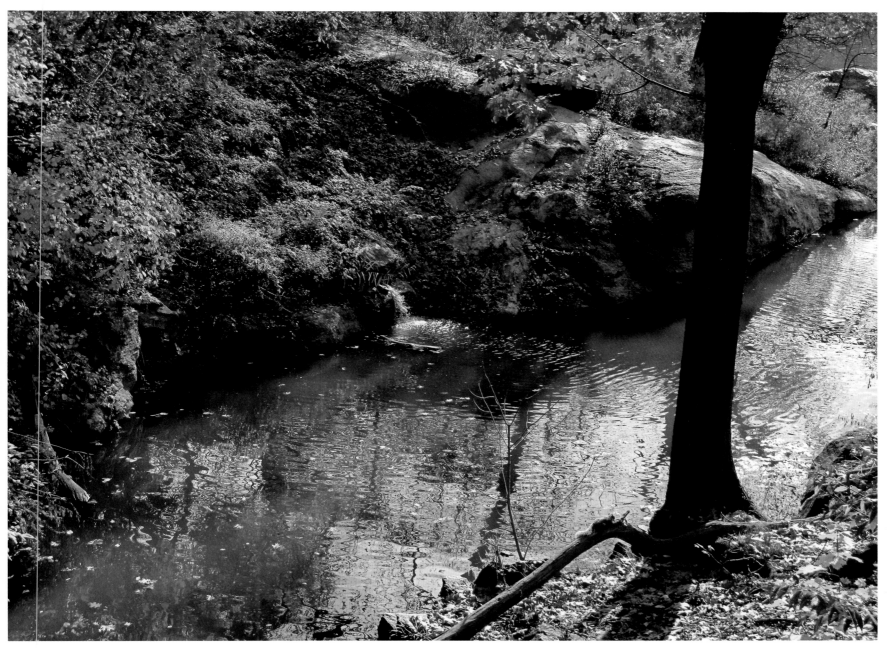

A new spring in the Inlet.

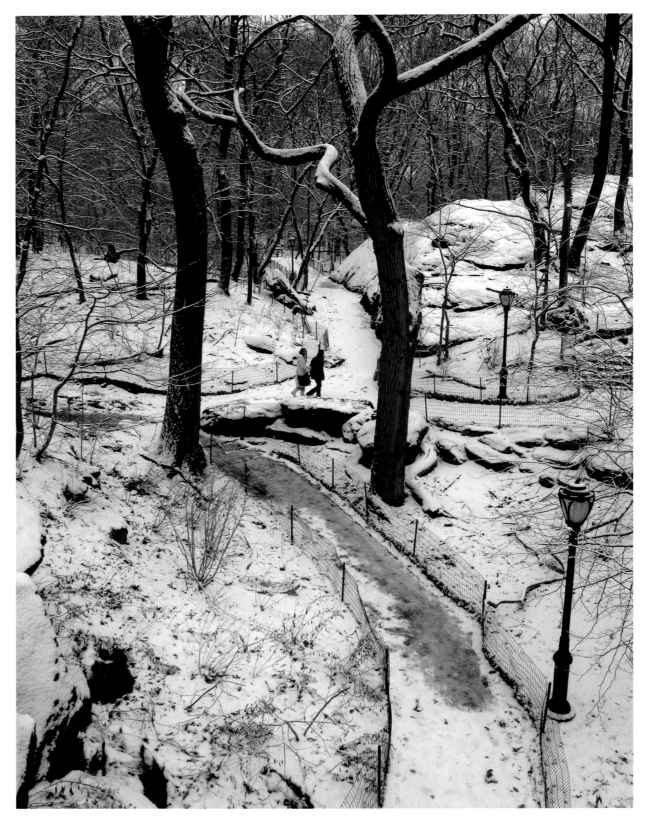

From the Ramble Arch in winter.

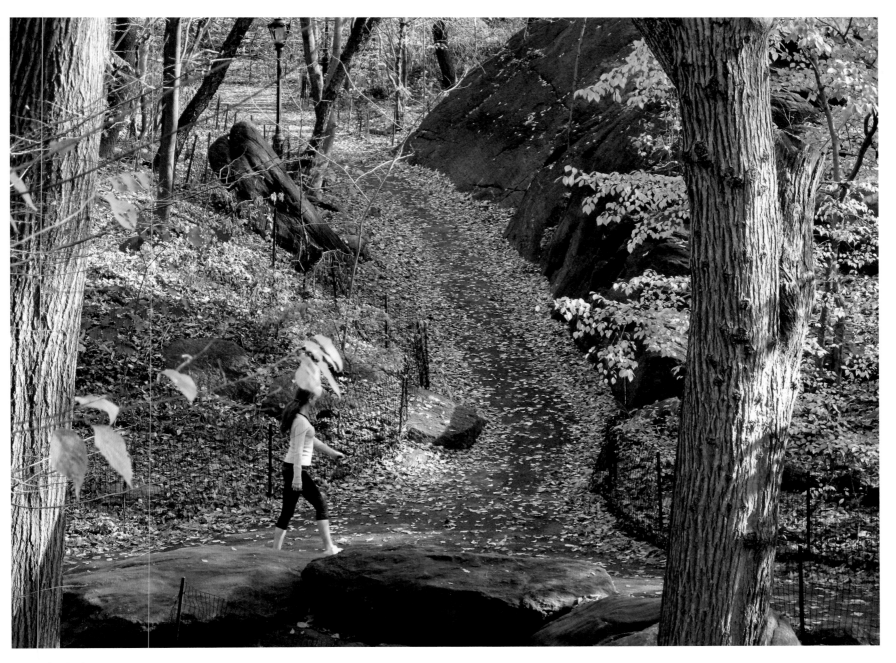

From the Arch.

A picnic near Mugger's Woods.

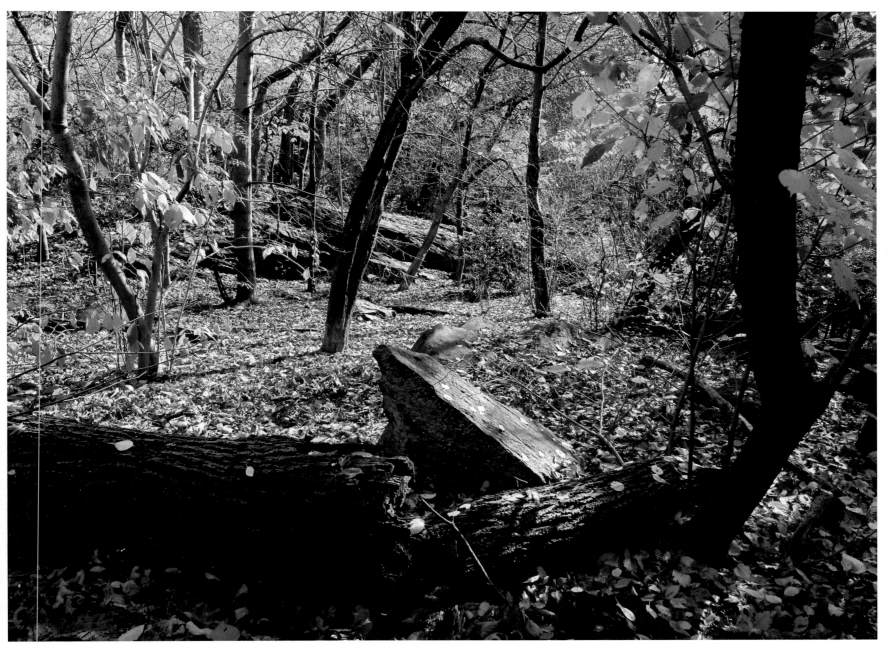

The small holly tree (at center) was planted by the Conservancy a few years earlier.

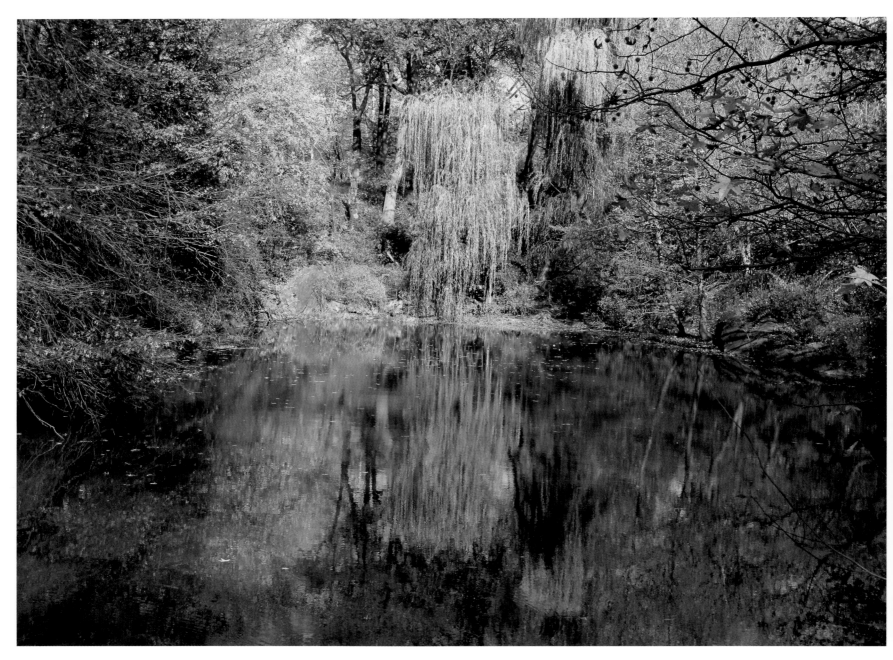

The Upper Lobe.

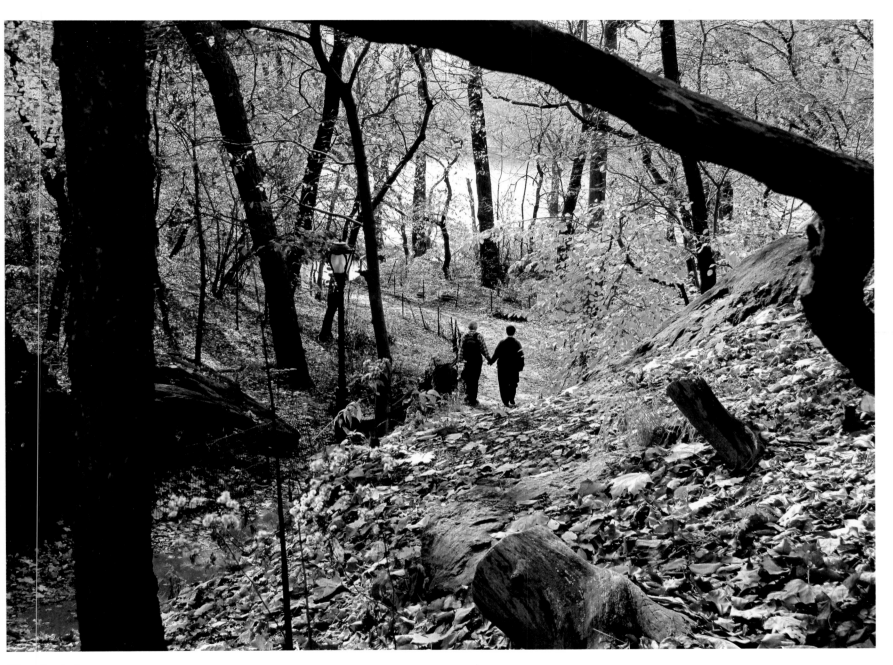

Near the Arch.

Dogwood.

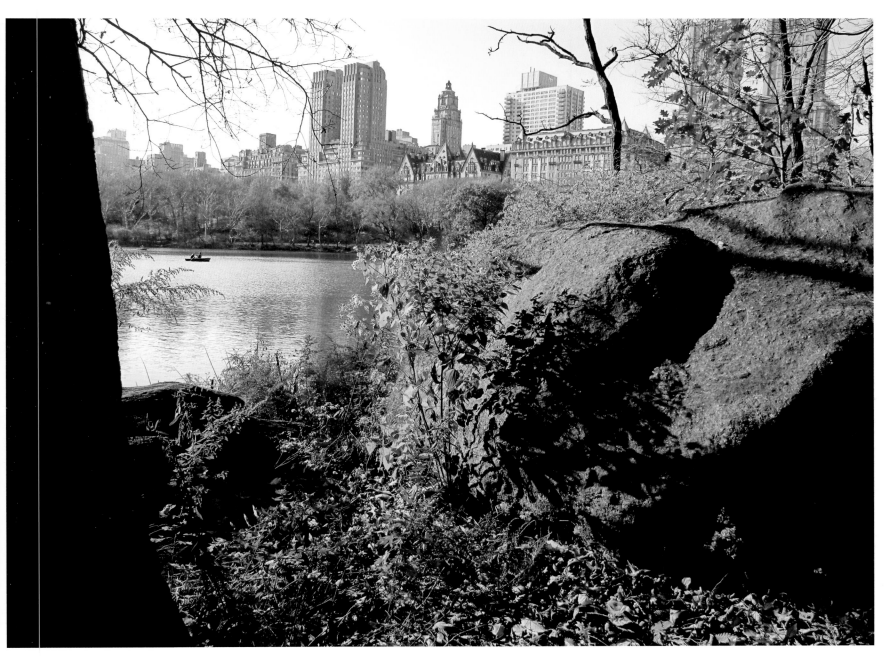

Near the Cave.

Strange to say, there are hundreds if not thousands of persons, of both sexes, in New-York City who have never taken a walk through the Ramble in the Central Park. There can be only one reason for this, and that must be, that they are unacquainted with its varied beauty, its cool shade, labyrinthian walks, and fragrant flowers… The Ramble is the loveliest spot for afternoon walks and pleasant musings to be found within ten miles of New-York.

— *The New York Times*, July 24, 1860

ACKNOWLEDGMENTS

Ihave been helped in this project in many ways by many individuals. I am grateful first to that wonderful organization called the Central Park Conservancy, and to some remarkable individuals there, including Douglas Blonsky, Regina Alvarez, Sara Cedar Miller, and Kari Wethington. Regina has been generous with her time and knowledge in identifying myriad plants and I am most grateful for that. Sara is a distinguished photographer and the historian at the Conservancy. She has published two books on the park, and in the spring of 2011 her third Central Park book, on Strawberry Fields, was published.

I thank Scott Johnson for identifying our cartographer, Chris Kaeser, who has been a worthy successor to Gerard Mercator in mapping in detail this tract of Manhattan *terra incognita*. Thanks to the Greensward Foundation for allowing us to use material from *Rock Trails in Central Park* by Thomas Hanley and M. M. Graff, and to Phil Jeffrey for permitting us to quote from his Web site, www.philjeffrey.net. I thank Elizabeth Barlow Rogers for her beautiful essay on the ethos of the Ramble and its origins. She is the author of, among other books, *Romantic Gardens: Nature, Art and Landscape Design*. I thank Cal Vornberger for his insightful essay on the birds of the Ramble. He is the author of *Birds of Central Park* and maintains an informative Web site at www.calvorn.com. Thanks to Sidney Horenstein for writing so eloquently about the amazing, and amazingly complex, geology of the Ramble.

Thanks to Anna Pataki, Alexis Veroucas, Bob Abrams, and John Doyle for ideas that have contributed materially to this project. Thanks to Sue Medlicott for her excellent judgment on production matters, and to Massimo Tonolli and his team at Trifolio for their remarkable skill in reproducing photographic images. I am deeply indebted to Sherri Gill, Ken Siman, and Ann Espuelas for their fine work on this project. I thank Yannis Kouroudis, Daphne Sgourou, Yannis Kondilis, and Natasa Tsikoura for their help while I was working on this project in Athens. My profound appreciation to the team at Abbeville, including Bob Abrams, Susan Costello, Louise Kurtz, Misha Beletsky, and Michaelann Millrood. Misha is responsible for the fine design of this work.

The reader should know that the photographer was not equipped with GPS during his visits to the Ramble, so he asks understanding if we are off a few yards, or if a place name is different than the one you use. Remember that the park designers' idea was to get visitors (including photographers!) lost in these thirty-eight acres. Those exit signs *The New York Times* asked for in 1860 have never been put up. The Ramble has some "official" names (which sometimes change), and some popular names (which also sometimes change). Ken Siman, Jason Snyder, and a number of park rangers have contributed to our topographic knowledge, but I assume responsibility for any errors or omissions. If you have corrections please let me know and we shall include them in the next printing.

Lastly, let me say thank you to Jim and Mary Evans, our friends and neighbors. Jim was the Chairman of the Board of Trustees of Central Park Conservancy from 1985–91. It was through Jim that I first became aware of the wonderful things happening in Central Park. We are all indebted to him for applying his intelligence and charm to this patch of green at our doorstep.

—Robert A. McCabe

INDEX

Page numbers in *italics* refer to illustrations.

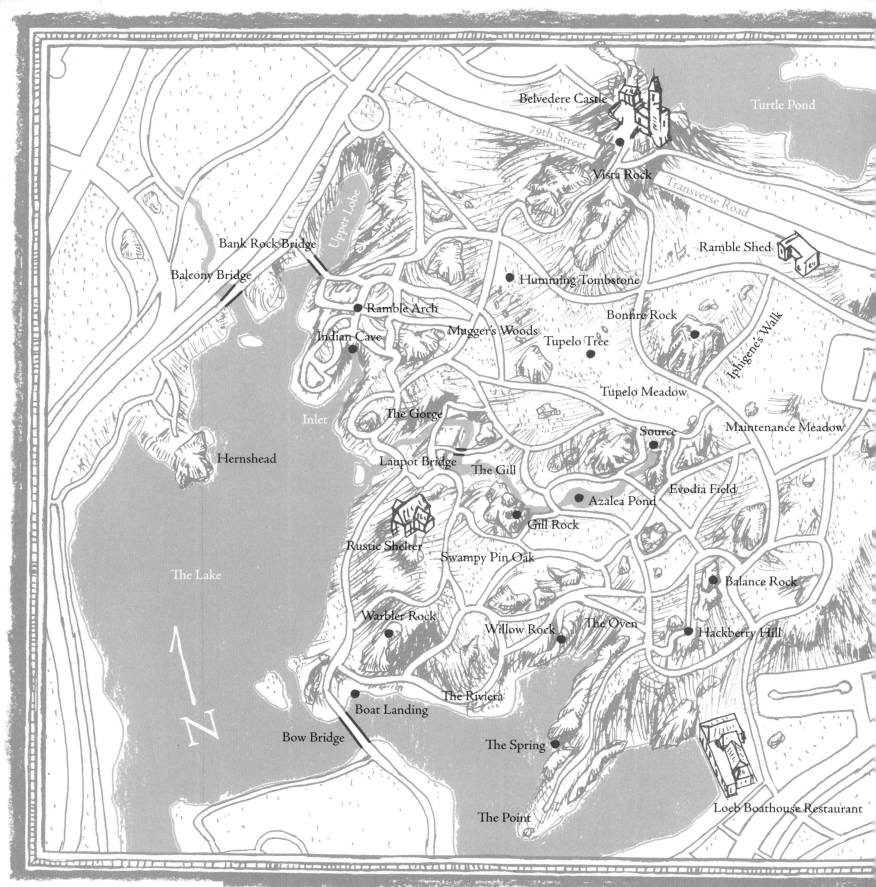